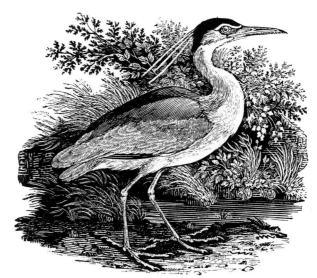

Bewick's engraving of the Night Heron:
enlarged on the Cover,
and here shown in its original size.

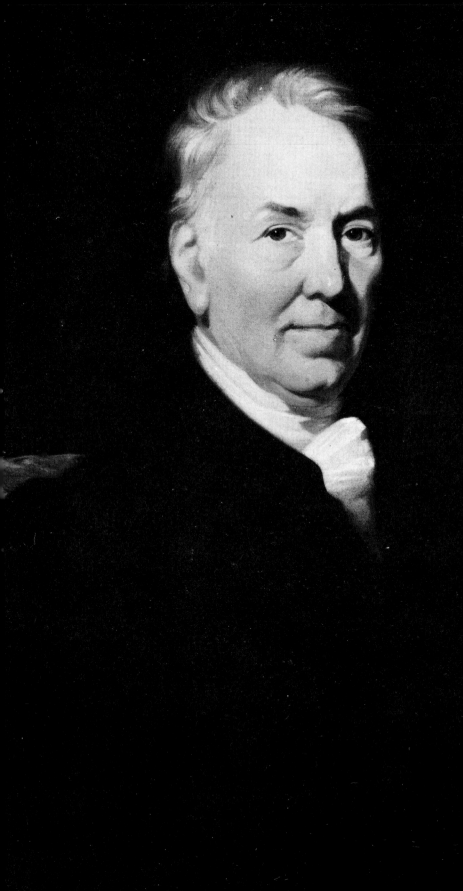

Thomas Bewick

AN ILLUSTRATED RECORD OF HIS LIFE AND WORK
BY IAIN BAIN

 THE LAING GALLERY

TYNE AND WEAR COUNTY COUNCIL MUSEUMS

Iain Bain © 1979
Published by Tyne and Wear County Council Museums
Sandyford House, Newcastle upon Tyne NE2 1ED
and printed in Great Britain by
G. Bailes and Son, Durham
ISBN 0 905974 02 6

FRONTISPIECE: Thomas Bewick
by James Ramsay, 1823
National Portrait Gallery

Contents

Bewick's trade card, possibly engraved late in life for his visit to Edinburgh in 1823. From an impression in Julia Boyd's *Bewick Gleanings*, 1886.

Acknowledgments

For generous assistance and permission to reproduce materials in their collections relating to Thomas Bewick and his work, particular thanks are due to the Trustees of the British Museum and the staff of the Department of Prints and Drawings, the Victoria and Albert Museum, the National Portrait Gallery, the Committee of Lloyds of London, and to the following societies and institutions in the city of Newcastle upon Tyne: the Society of Antiquaries, the Literary and Philosophical Society, the Natural History Society of Northumbria, and the Central Library. The Paul Mellon Centre for studies in British Art has given most generous financial assistance for the reproduction of Bewick's drawings.

Note on the Illustrations

Unless otherwise noted, all Bewick's engravings and drawings are reproduced in their original size. To make the best use of the space available the full paper area of the drawings is not always shown.

[6]

Introduction

Thomas Bewick's reputation as an artist-engraver on wood brought him a fame in his lifetime which has never since diminished. He had a particular genius for expressing in a miniature form – often with pathos or humour – his deeply felt affection and understanding of the manners and scenes of north country life, and the clarity of his observation was expressed with a virtuosity never since equalled.

Today, 150 years after his death, Bewick's work continues to be widely used in reproduction on a wide variety of articles with an equally wide range – and indeed sometimes a total lack – of sensitivity. While his work may be known, his identity as its creator all too often goes unrecognised or unacknowledged. The inherent charm of the small vignette form which Bewick made so much his own and which combines so happily with much graphic design, still has a great appeal. But Bewick was a miniaturist and the temptation provided by the camera and its capacity for enlargement has done him little justice; and frequently when credit has been given to Bewick's name, it has been attached to reproductions of engraving vastly inferior to the authentic originals.

Ever since the first substantial account of his work appeared in the *Annual Review* of 1805, Bewick has been the subject of a continuing stream of articles and books. Much of what has been written about him has been based on misconception and oft-repeated myth. There has of course been a good measure of perceptive and more balanced understanding, but even here the surprising fact remains that until very recently little use has been made of a large residue of original business records, documents and letters – now alas widely scattered but for the most part reasonably accessible. These documentary sources are now beginning to encourage the right kind of enquiry, although much work remains to be done before a fuller and more accurate account can be written of a not altogether simple character and the multifarious business activities, processes and techniques that supported the creation of his art.

The 150th anniversary exhibition held at the Laing Art

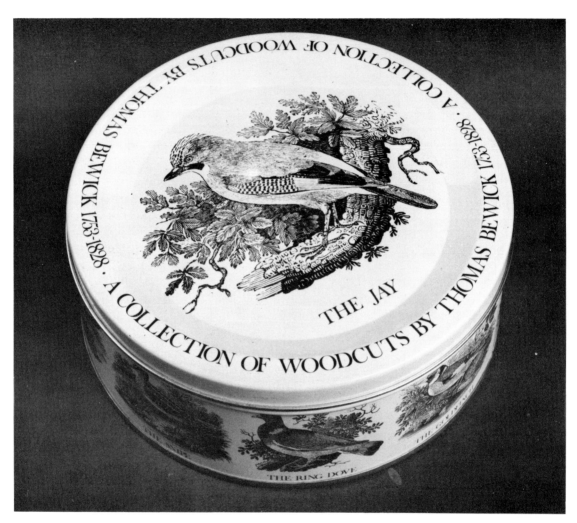

1. A chocolate tin decorated with enlarged and reduced reproductions of figures from the *British Birds*, printed in violet on white, 1976.

Gallery in the summer of 1978, set out to place an extensive showing of Bewick's genius as draughtsman and watercolourist within the broader context of his working life, and thus to emphasise the seldom fully recognised fact that the wood engraving by which he is now remembered was the extraordinary by-product of a hard and busy life as a trade engraver on metal. The same principle has been applied to the compilation of this picture book which has been designed to serve as a brief general introduction, but which, with its selection of more than 250 illustrations, presents a more comprehensive visual record than has hitherto been attempted.

* * * *

2. Further contemporary applications of work from Bewick's *Birds* and *Quadrupeds* – a quarter-size chamber pot, greeting cards, wall cards hideously coloured, and transparent tile stickers.

'At length we reached the dwelling of the Engraver, and I was at once shewn his workshop. There I met the old man, who, coming towards me, welcomed me with a hearty shake of the hand, and for a moment took off a cotton night-cap, somewhat soiled by the smoke of the place. He was a tall stout man, with a large head, and with eyes placed farther apart than those of any man I have ever seen: – a perfect old Englishman, full of life, although seventy-four years of age, active and prompt in his labours. Presently he proposed shewing me the work he was at, and went on with his tools. It was a small vignette, cut on a block of boxwood not more than two by three inches in surface, and represented a dog frightened at night by what he fancied to be living objects, but which were actually roots and branches of trees, rocks and other objects bearing the semblance of men. This curious piece of art, like all his works, was exquisite. . . . The old gentleman and I stuck to each other, he talking of my drawings, I of his wood cuts. Now and then he would take off his cap, and draw up his gray worsted stockings to his nether clothes; but whenever our conversation became animated, the replaced cap was left sticking as if by magic to the hind part of his head, the neglected hose resumed their downward journey, his fine eyes sparkled, and he delivered his sentiments with a freedom and vivacity which afforded me great pleasure. . . . I revisited him on the 16th April, and found the whole family so kind and attentive that I felt quite at home. The good gentleman, after breakfast, soon betook himself to his labours, and began to shew me, as he laughingly said, how easy it was to cut wood; but I soon saw that cutting wood in his style and manner was no joke, although to him it seemed indeed easy. His delicate and beautiful tools were all made by himself, and I may with

[9]

truth say that his shop was the only artist's "shop" that I ever found perfectly clean and tidy. . . .'

This engaging portrait of Bewick was written by his celebrated American contemporary John James Audubon in recollection of a visit to Newcastle in 1827. Though often quoted its vividness loses nothing in the retelling. At the time of their meeting Bewick was nearing the end of his life, while Audubon was setting out on a British tour to secure engravers and subscribers for the massive folio work on the birds of America that was to establish his fame. The two men took greatly to one another and their respective skills. No two styles could have been more different, and no doubt this want of direct rivalry made the expression of mutual admiration that much more easy for them both. While Audubon's work was large, highly finished and essentially decorative, Bewick was happiest on a small scale which suited his marvellously penetrating eye; many of his subjects were packed with incident, told a tale or pointed a moral with a powerful depth of feeling. In 1853 the artist C. R. Leslie wrote of him in his *Handbook for Young Painters*: 'While speaking of the English School, I must not omit to notice a truly original genius, who, though not a painter, was an artist of the highest order in his way – Thomas Bewick, the admirable designer and engraver on wood. His works, indeed, are of the smallest dimensions, but this makes it only the more surprising that so much of interest could be comprised within such little spaces. The wood-cuts that illustrate his books of natural history may be studied with advantage . . . – filled as they are by the truest feeling for Nature, and though often representing the most ordinary objects, yet never, in a single instance, degenerating into commonplace. . . . The student of Landscape can never consult the works of Bewick without improvement. . . .'

Bewick was born in August 1753 at Cherryburn, a small farm on the south bank of the river Tyne, some twelve miles west of Newcastle. His father was tenant both of the farm and of a nearby colliery from which the family mined coals for local sale. Thomas was the eldest of eight children and as a boy had to do much to assist his family in their labours around the farm and mine workings. This background and his constant delight in the neighbouring countryside – which led him into many a truancy – had the greatest influence on the work Bewick produced in the days of his fame. His final years of rudimentary schooling under the parson Christopher Gregson at the nearby village of Ovingham, had much to do with his later vigorous moral outlook on life.

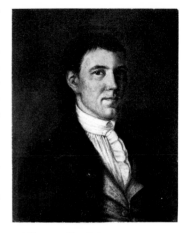

3. Thomas Bewick as a young man, by George Gray. $22\frac{1}{2} \times 18$ in. c. 1780. *Laing Gallery.*

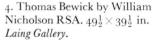

4. Thomas Bewick by William Nicholson RSA. $49\frac{1}{2} \times 39\frac{1}{2}$ in. *Laing Gallery.*

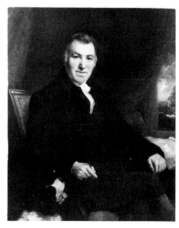

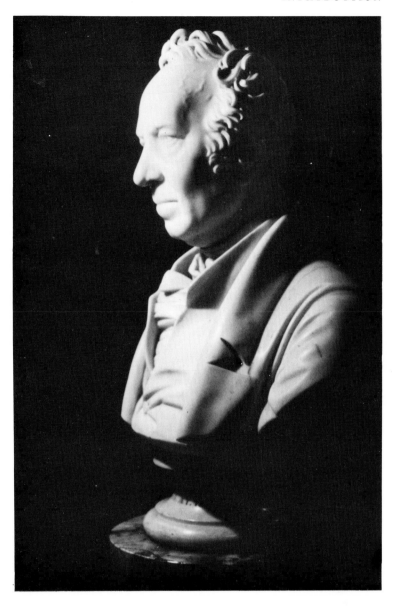

5. Marble bust of Thomas Bewick by E. H. Bailey RA, taken from a life mask in 1826. *Literary & Philosophical Society of Newcastle upon Tyne.*

It has at times been fashionable to look upon Bewick as a simple unlettered rustic, but as with Burns the poet, the popular idea of the 'peasant genius' cannot be supported by the facts. His father, in the few of his letters that survive, appears as a literate and articulate man, aware of his relatively humble position, yet proudly firm in support of his rights. Bewick's own correspondence, much of which survives, as well as his autobiographical *Memoir*, totally refute the simple romantic view of him.

When he was fourteen, his godmother's friendship with the

talented Beilby family – engravers, jewellers and enamel painters in Newcastle – brought him to an apprenticeship with Ralph Beilby who a year earlier had established the only general engraving business in the town. This great good fortune provided exactly the right opportunity for Bewick to develop his early-born talent as a draughtsman. The then rapid growth of Newcastle's prosperity, based on the coal trade and the industries it supported, provided the workshop with a very wide range of work, and the contacts the young Bewick made with its extraordinarily diverse customers, many of them men of talent and learning, was to bring him lasting benefit throughout his life.

By the time his apprenticeship had come to an end, Bewick has turned his hand to every kind of engraved work on metal, and his particular success with engraving on wood, which came increasingly to the workshop, and for which his master had no special liking, brought him a prize from the Society for the Encouragement of Arts. For two years afterwards he worked at home before deciding to try his fortune in London. But his stay there was short-lived: the contrast of its hurry and bustle after his renewed contact with the delights of the countryside – he had just completed a five-hundred mile tour on foot through the highlands of Scotland – was too much. He returned north to Newcastle after nine months. Uncertain about setting up in competition with his former master, he was eventually persuaded by a mutual acquaintance to join Beilby in a partnership that was to last twenty years and during which he produced his two great works of natural history – the *General History of Quadrupeds*, 1790, and the first volume of the *History of British Birds*, 1797. His life was a creative one, too full for travel and adventure, but his fascinating correspondence shows us a life of great diversity of acquaintance and interest. He lived through stirring years of industrial and intellectual development in which the town of Newcastle was much a part. The great success of his natural histories brought him letters from far and wide as the popular interest in their subject quickened. He was never happier than when in the company of a small group of like-minded cronies, or when at his own fireside with his son and three daughters. His delight in walking, angling, and the music of the Northumbrian pipes brought him much comfort after long hours at the workbench. Letters written to his children when away from home show him to have been a kindly and loving father though not without a touch of solemn severity; in his business dealings he appears as easy to take offence and ill-

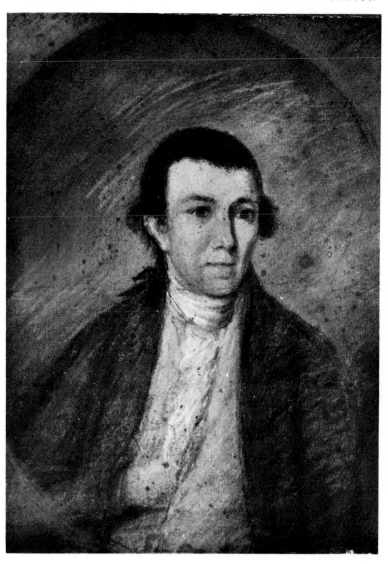

6. John Bewick by George Gray
c. 1780. 15 × 12½ in. *Natural
History Society of Northumbria.*

disposed to give ground in a compromise. Severe illness in 1812
at the age of 59, brought him to semi-retirement. His son
Robert took on the day-to-day business, leaving him to devote
himself to the illustration of his last completed book, the *Fables
of Aesop*, which he published in 1818, as well as to the improving
of subsequent editions of the natural histories. His eldest
daughter Jane became his principal help in the administration
of the business. Jane and the second daughter Isabella were to
live on until the 1880s – jealous guardians of their father's relics
and of his reputation. Bewick died in November 1828, active in
mind to the end. On his deathbed, when asked what was

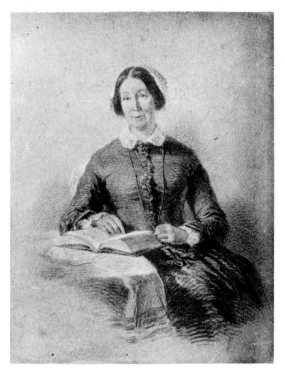

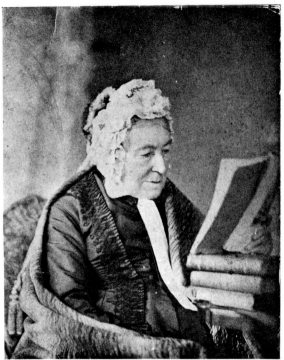

7. Bewick's eldest daughter Jane aged 65, by Sir John Gilbert, 1852. *Original not traced; photograph in private collection.*

8. Jane Bewick in old age. *Natural History Society of Northumbria.*

occupying his thoughts, he replied that he had been devising subjects for new tail-pieces.

It was Bewick's continued contact with the countryside that fed his genius. His love for his birthplace, which he kept alive by frequent weekend visits while an apprentice and through his brother William's continuance of the tenancy after their father's death, is very clearly seen in some of the most attractive passages of his *Memoir*: '– From the little Window at my bed head I noticed all the varying seasons of the year, and when the Spring put in, I felt charmed with the music of Birds . . . – The chief business imposed upon me as a task at this season, was in my being set to work to scale the pastures and medows, that is spreading the Molehills over the surface of the ground – this & Gardning & such like jobs was very hungry work, and often made me think dinner time was long in coming, & when, at last, it was sent to me, be what it would I sat down on the *lown side* of a hedge & eat it with a relish that neaded no Sauce. – As soon as the Bushes & Trees began to put forth their buds & made the face of nature look gay – this was the signal for the Angler to prepare his fishing Tackle & in doing this, I was not behind hand, with any of them in making my own all ready –

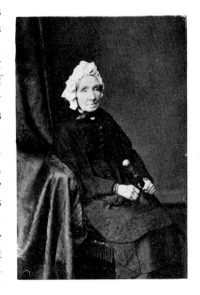

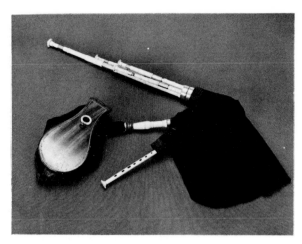

10. Robert Bewick's Northumbrian
small-pipes. The chanter which is
of the primitive keyless type is
probably not original. *Society of
Antiquaries, Newcastle upon Tyne.*

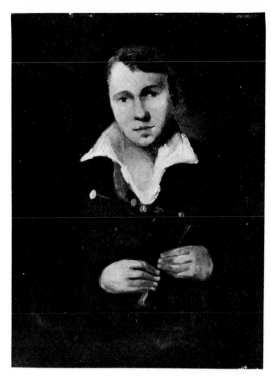

11. Robert Elliot Bewick as a boy,
by John Bell. 28×24 in. *Natural
History Society of Northumbria.*

12-13 Entries from Bewick's Cash
Books recording payments to
John Peacock, piper and town
musician, for Robert's lessons on
the pipes, and for a new chanter.
Laing Gallery.

9. Isabella, Bewick's second
daughter and longest surviving
child. *Natural History Society of
Northumbria.*

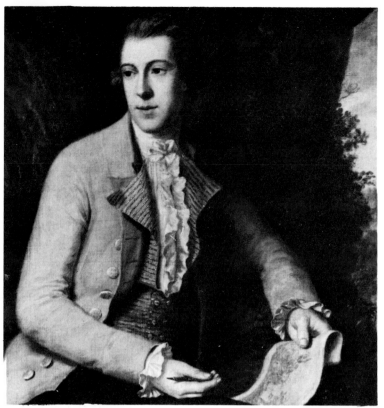

14. Robert Pollard, 1755-1838 by Richard Samuel, 1784. 48¾ × 39 in. (detail). *National Portrait Gallery.* Pollard was a lifelong friend and correspondent of Bewick. After apprenticeship in Newcastle he went south to London and established himself as an engraver of both his own and other artists' work. His son James later became well known as an engraver and painter of coaching scenes.

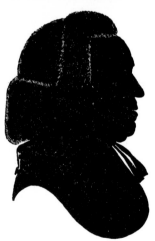

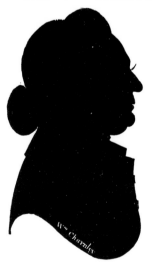

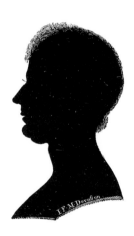

15-17. This group of three silhouettes were of an uncompleted series intended for Bewick's autobiographical *Memoir*. LEFT: The Revd. Christopher Gregson 1738-1809, while incumbent at Ovingham gave Bewick a few important years of schooling before his apprenticeship. CENTRE: William Charnley, 1727-1803, bookseller in Newcastle and publisher of children's books which included much of Bewick's early work. RIGHT: John F. M. Dovaston, 1782-1854, of Westfelton, Shropshire, amateur of natural history and 'much valued friend' of Bewick's later years and to whom Bewick wrote one of the most interesting series of his letters to survive.

18. William Bulmer, 1757-1830.
An engraving published by the
Gentleman's Magazine in 1830 as an
obituary portrait. Like Pollard,
Bulmer went south from
Newcastle to become proprietor
of the Shakspeare Press and the
most celebrated printer of his day.
For Bulmer, Bewick and his
brother John engraved blocks for
two books now much prized by
connoisseurs of typography and
book production: Somervile's
The Chase, 1796, and *Poems by
Goldsmith and Parnell*, 1795.

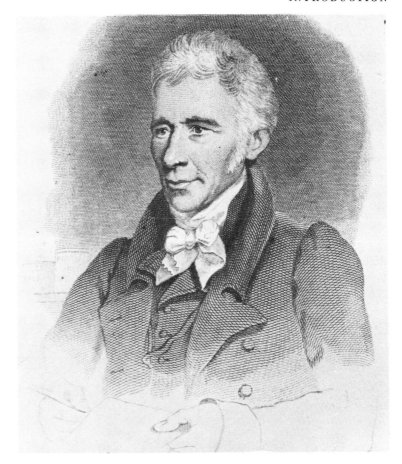

19. Bewick was a convivial man,
though seemingly prefering the
small group of close cronies. This
card, which he engraved himself,
records his membership of one of
several similar groups in
Newcastle — most of them formed
for the discussion of politics and
the affairs of the day. *Trustees of
the British Museum.*

Fishing Rods – Set Gads & night lines were all soon made fit for use & with them late & early I had a busy time of it during the long Summer Months & untill the frosts of Autumn, forbid me to proceed – The uneasiness, which my late evening wadings by the Water side, gave to my father & mother I have often since reflected upon with regret – they could not go to bed with the hopes of getting to sleep, while haunted with the apprehension of my being drowned, & well do I remember to this day, my father's well known Whistle which called me home – he went to a little distance from the House, where nothing obstructed the sound, & whistled so loud through his finger & thumb – that in the still hours of the Evening, it might be heard echoing up the Vale of the Tyne to a very great distance –'

Newcastle in the days of Bewick's youth was still a relatively small town which retained much of its medieval character. Its ancient bridge across the Tyne still had houses along its length,

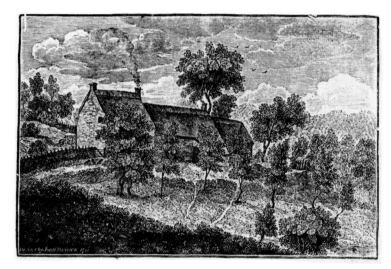

20. Cherryburn, Bewick's birthplace, viewed from the orchard at the back of the house, and to the east. Drawn and engraved by John Bewick in 1781 and later finished by his brother. (Printed as a frontispiece to Bewick's *Memoir*, 1862.)

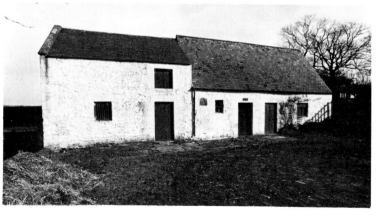

21. Cherryburn today, from the west and as it stands as part of the steadings of the larger farmhouse built by Bewick's relatives in the 1830s.

22. A drawing by John Bewick. The background shows a pit-head and a horse-drawn 'gin' or winding gear: it may possibly depict the family's rented colliery at Mickley on the hillside above Cherryburn. *Trustees of the British Museum.*

23. A view of the Tyne at Bywell with the ruined bridge, by Bewick's apprentice Luke Clennell, watercolour, c.1800. A scene familiar to Bewick in his childhood. *Laing Gallery.*

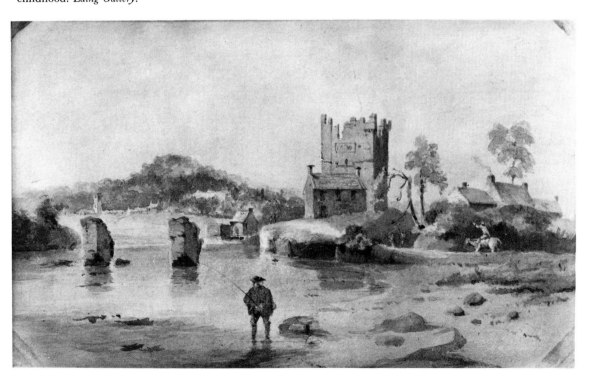

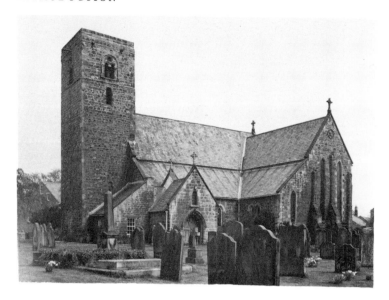

24. Ovingham Church today, scene of many of Bewick's childhood pranks. His grave lies at the foot of the tower. *Photo courtesy Marshall Hall.*

and there were many of the old gateways to its walls still standing. The countryside was near at hand and clearly in view from the house on its western outskirts in which Bewick lived during the first twenty-six years of his marriage. He was always glad to be out of the bustle even of so small a town, whenever opportunity afforded. His description of leaving home to be apprenticed speaks vividly of the sadness of his forsaking the country life: ' –the eventfull day arrived at last, and a most grievous day

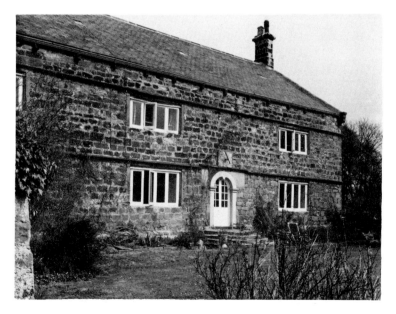

25. Ovingham vicarage, where Bewick received the few important years of schooling under the Rev. Christopher Gregson before his apprenticeship. *Photo courtesy Marshall Hall.*

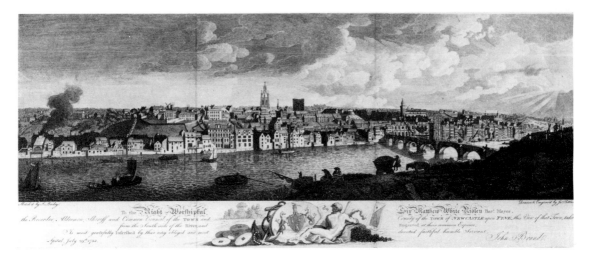

26. Newcastle in 1781, from Brand's *History and Antiquities of Newcastle*, 1789. The coal-carrying keel boats can be seen on the River Tyne; the lantern spire of St Nicholas' church marks the churchyard site of Bewick's workshop.

it was to me – I liked my master, I liked the business, but to part from the country & to leave all its beauties behind me, with which I had all my life been charmed in an extreme degree, & in a way I cannot describe – I can only say my heart was like to break, and as we passed away – I inwardly bid farewell, to the whinney wilds – to Mickley Bank, the Stob Cross hill, to the water banks, the woods, & to particular trees, and even to the large hollow old Elm which had lain (perhaps) for centuries past, on the haugh near the ford we were about to pass & had

27. St Nicholas' Churchyard, by Ralph Waters, c.1789. Taken from the south-east corner, it gives the view from the site of Bewick's final workshop. Bewick engraved small work on metal for Waters, who in turn once painted him a shop sign. *Laing Gallery*.

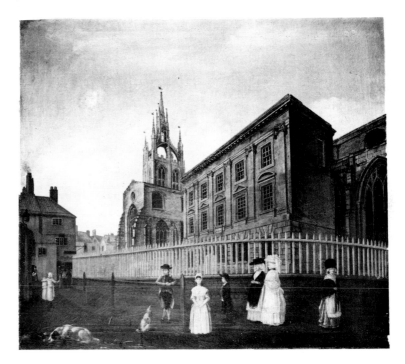

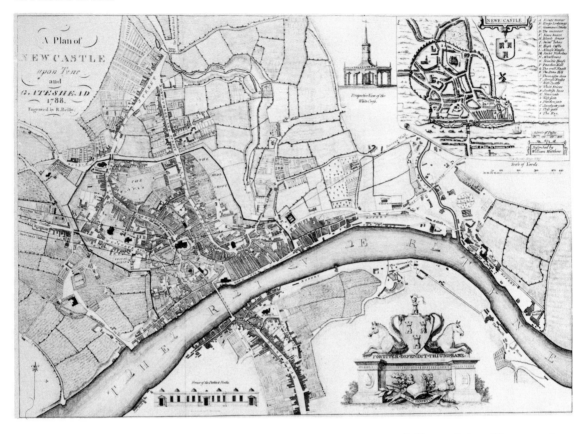

28. Newcastle in 1788, engraved by Ralph Beilby for Brand's *History and Antiquities of Newcastle*, 1789.

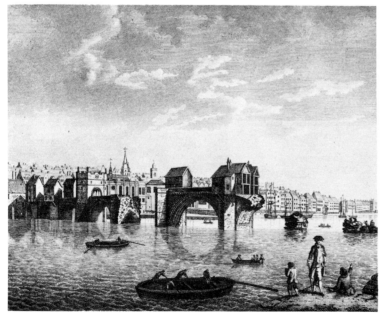

29. The ruins of the old house-bearing bridge across the Tyne after the great floods of 1771 — the fourth year of Bewick's apprenticeship. Engraving from Brand's *History and Antiquities of Newcastle*, 1789 (detail).

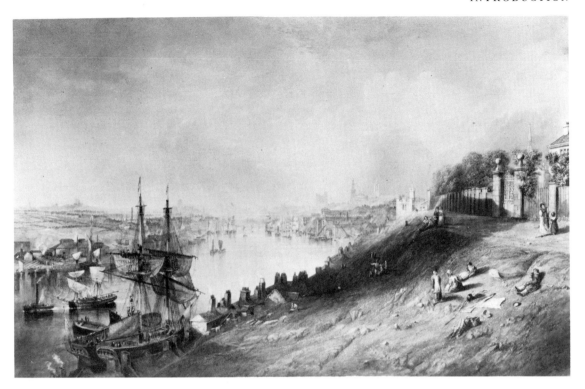

30. Newcastle from St. Anne's Church, 1835. Watercolour by J. W. Carmichael. *Laing Gallery.*

sheltered the Salmon-fishers while at work there, from many a bitter blast –'.

* * * *

Bewick's relationship with the Beilby family was not an easy one. Of his good fortune in being brought to their company there is no question. They were greatly talented in many skills, William and Mary as glass enamellers in particular, but they assumed a certain social standing by which their country boy apprentice was made to feel an inferiority. Their condescension long rankled with Bewick and his family; and when the partnership was long established Ralph Beilby, who no doubt in some degree still saw himself as master, could see no harm in his running of an entirely separate business on the side – for the manufacturing of watch glasses – in which Bewick had no part. There was clearly a good deal of mutual affection and regard between the two men, but their natures were very different and there were a number of occasions when they were unable to see eye to eye – the dispute over Beilby's part in the authorship of the *British Birds* being one of them: he wanted his name on

[23]

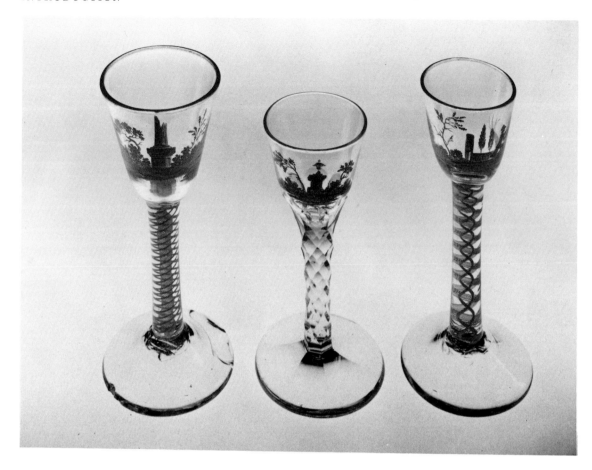

the title of what Bewick, not without reason but certainly un-generously, saw as a joint compilation. Beilby's genteel wife may well have added to the difficulties – she denied Bewick access to her husband's deathbed and he was not invited to the funeral.

31. Three wine glasses decorated in enamel by the Beilby family c.1770. *Long loans to the Laing Gallery.*

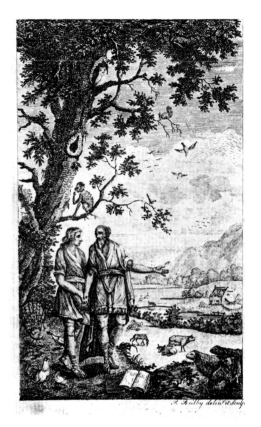

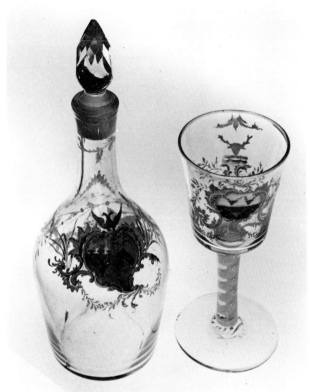

32. Frontispiece to the *Select Fables*,
1784, engraved by Ralph Beilby.
Pease Collection.

33. Decanter and goblet decorated
in coloured enamels by the Beilby
family, c.1770 *Laing Gallery.*

34. Engraved vignette bookplate
for the Rev. John Brand, historian
of Newcastle, by Ralph Beilby,
c.1770. From an impression in
Julia Boyd's *Bewick Gleanings*, 1886.

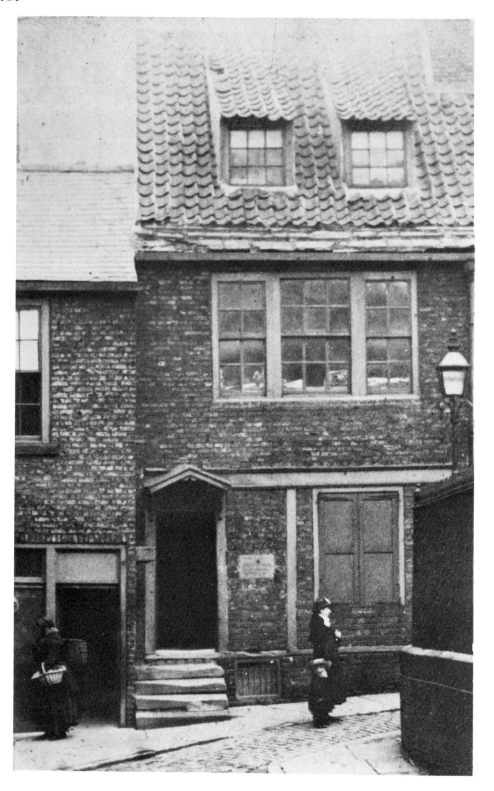

The Workshop

When Bewick came to Ralph Beilby's workshop as an apprentice the business was already concerned with metal engraving of every sort – for the decoration and inscribing of gold and silver rings, boxes, salvers, tankards, cutlery and dishes, brass clock faces, swords, guns, harness and dog collars – and for the production of banknotes, trade cards and billheads. Of Beilby Bewick wrote: 'I think he was the best master in the World for learning Boys, for he obliged them to put their hands to every variety of Work . . . he undertook everything & did it in the best way he could – he fitted up & tempered his own tools & learned me to do the same – this readiness to undertake brought him an overflow of work . . .'. Although Beilby was already en-

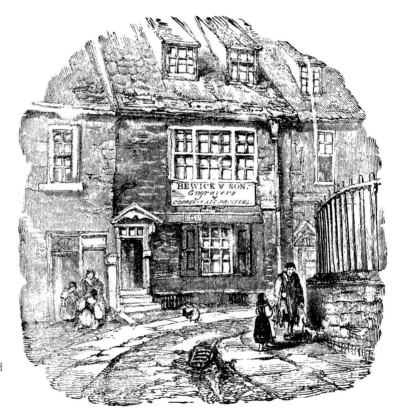

35. A late nineteenth-century view of Bewick's workshop, on its final site in the south-east corner of St Nicholas' churchyard. Enlarged from a small photograph recently rediscovered in a scrapbook. *B. Collingwood Stevenson.*

36. Bewick's workshop as engraved by his former apprectice John Jackson for his *Treatise on Wood Engraving*, 1839.

graving on wood in a small way, before Bewick joined him, engraving on metal and copperplate printing continued to predominate throughout Bewick's life. The fact that the celebrated wood engravings were a relatively small part of the day's work is often overlooked. The emphasis is clear on the billheads of the business, and is confirmed in the openings from the weekly engraving books reproduced here and selected from three distinct periods of Bewick's working life. During the first week of his apprenticeship no wood engraving was done; in the second week a single entry reads 'The N'Castle Arms on Wood' amongst all the other commissions being worked on metal. Likewise there was no wood engraving done during the first week of the partnership. By 1800 when Bewick was on his own the record becomes more personal and we see references to the apprentices: in the example reproduced the absence of Charles Hickson is recorded, along with notes on the wood engravings currently on hand for his own second volume of *Birds*, some of the tail-pieces being named. But the emphasis on metal engraving remains.

Not enough evidence has yet come to light to give us precise details of the size and arrangement of the workshop, but the working engraver needed relatively little space. During the main period of the partnership between Beilby and Bewick they had two and sometimes three apprentices working with them, and usually two copperplate printers. When Bewick's son Robert

37. A group of Beilby and Bewick's workshop account books. *Laing Gallery*.

Br.ᵗ over " "
a M. ring " 1 6
Cutting a seal for the Reg.ᵗ ――
28.ᵗʰ to Oct 5ᵗʰ
 Fini.ᵈ the veal 1 . 1 . "
 a bill of fare " 10 . 6
 Crest on a can " " 4
 D.ᵒ on a tankard " " 4
 2 Collars " 1 "
 Crest on a teapot " " 4
 D.ᵒ on 2 labels " " 6
 D.ᵒ on a Gugler " " 2
 a Collar " " 6
 a Cypher veal " 6 "
 Coat of Arms on a veal " 6 "
 Cypher on a punch ladle " " 6
 Name on a knife " " 4
 3 . 9 . 2

Oct 5ᵗʰ to 12ᵗʰ
a Steal veal w.ᵗʰ Arms " 10 . 6
Crests on 6 tables " 1 . 6
a bill of parcels " 7 . 6
Cypher on 6 tables " 1 . 6
Crest on a mustard & spoon " " 6
Name on a Whip " " 6
2 plates for a tea chest " 1 "
a Steal veal w.ᵗʰ Arms " 10 . 6
 1 . 13 . 6

12ᵗʰ to 19ᵗʰ
Engrav'd a twenty note 1 . 10 . "
The N Castle Arms on wood " 5 . "
a Collar " 1 . "
a Whip " " 6
Crest on a soup spoon " " 4
a Collar " " 6
a Steal veal " 15 . "
 2 . 12 . 4

38. The Weekly Engraving Book showing the entry for the first week of Bewick's apprenticeship. *Laing Gallery.*

July 20ᵗʰ to Aug.ᵗ 4ᵗʰ
 " "
2 motto rings " 3 "
Cypher on a silver seal 2 . 6
D.ᵒ on a steel D.ᵒ " 3 . 6
2 pieces hair work " 3 "
Cypher 6 tables " 1 . 6
3 Crests " 1 "
a suit Clock work " 4 "
Crests 12 knives " 3 "
a set of Lr.ˢ Repaird " 3 "
2 Cyphers " 1 "
12 D.ᵒ " 3 "
2 Collars " 1 "
 1 . 9 . 6
Addition to 5.ˢ Plate
Clark " 10 . 0
addition to Map of " 5 . "
England 2 . 5 . "

Aug 4 to 11 R.B. & T.B.
Arms &c on a Tomb.ᵈ " 7 . 6
Cypher on a Waiter " 2 . 6
D.ᵒ & Crests on a Kettle " 3 . "
Crests & Bottle stand " 1 "
Arms on 2 tureens " 3 "
Cypher 3 Lr.ˢ " 10 . 6
Crests 12 knives " 3 "
Cypher 12 bar " 2 6
D.ᵒ 2 tables " " 6
6 Crests " 1 . 6
Inscrip.ⁿ on a B.ᵈ Baskt 1 "
a suit Clock work " 3 "
Harness Crests " 7 "
4 motto " 3 "
6 Collars " 3 "
 2 . 12 "

39. The Weekly Engraving Book showing the entry for the first week of Bewick's partnership with his former master Beilby. *Laing Gallery.*

40. The Weekly Engraving Book showing entries for the year 1800 by which time Bewick was in business on his own. *Laing Gallery*.

died in 1849, we do know that the accommodation consisted of a front office ('long bench, long table, square bench, and two desks') – a printing office for copperplate work ('two printing presses, and a long bench') – a back office ('one bench') – a kitchen and 'necessary' – and two garret rooms. Printing in the workshop was confined to the production of engraved work from copper plates, particularly banknotes and billheads. Wood engravings were proved and printed by other businesses in the town.

The account books of the business provide an unparalleled source of information for students of engraving and copperplate printing; much detail relating to the book trade's selling and distribution methods can also be found in them. Nearly one hundred volumes have survived, representing a good deal more than half of the probable total, and apart from three in the Victoria & Albert Museum all of consequence are now in the care of the Laing Art Gallery, Newcastle. The information con-

tained in them is varied and not consistent. The main series are the Day Books, Cash Books, Single-entry Ledgers, Weekly Work Books for the engraving shop, Work Books for the copperplate printing shop, and Press Books recording the printing shop expenditure. Double-entry ledgers were kept for only a few special projects. Their content is fascinating and frequently there is delightfully human detail to be found in them. In recent years scholars have made important use of the books in research on the Newcastle silversmiths for whom much work was done, and on the pottery and glass trades of the town: copperplates were engraved for the printing of decorative transfers for pottery, and lettered moulds were made for the glass bottle manufacturers. Business came to the workshop not just from Newcastle: in Bewick's correspondence there are letters of commission from tradesmen in more than fifty towns throughout Britain.

41. A bill made out to the Beilby-Bewick partnership by Beilby's Watch-glass enterprise. *Iain Bain.*

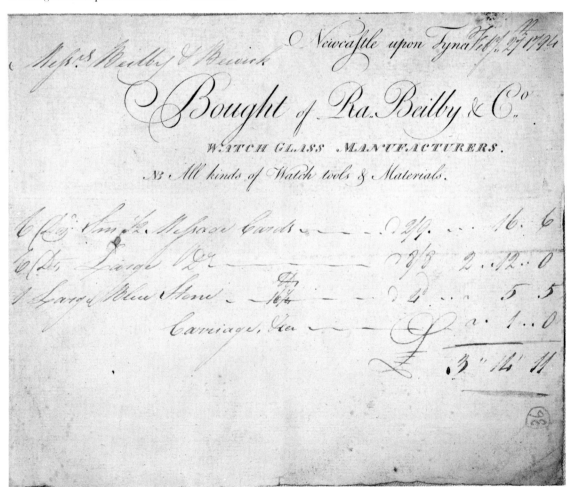

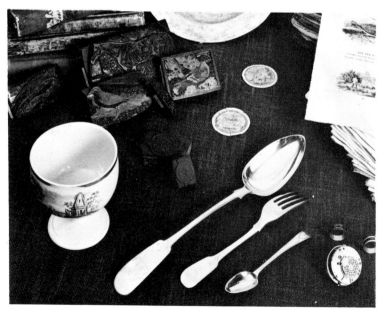

42. Silver gilt punch bowl engraved in the workshop, 1791; Admiral Keppel's gold Freedom box, engraved in the workshop, 1779 and presented by the Corporation of Trinity House, Newcastle; engraved clock face typical of many that passed through the workshop. *Laing Gallery*.

43. A group of objects typical of the variety of jobs that passed through the workshop: silver spoons, mourning rings, a watch movement, wood engravings, and a piece of pottery carrying transfer printed decoration from a copper engraving. *Laing Gallery*.

45. Bewick's tool box as it was left at the time of his death. He continued to work to the end, mostly in touching-up and repairing the blocks for his own books. The curved round surface at the left is a leather-covered lead casting (nowadays leather filled with fine sand) used to give the engraver greater freedom when turning the woodblock to cut curved lines. *Pease Collection.*

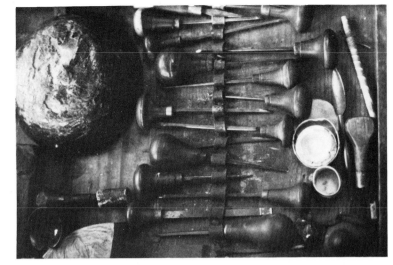

44. A group of graver points, lit to show the variety of section and face required by the wood engraver.

Engraving on Wood

Like the letter types of the text it was often designed to accompany, the engraved wood block presents an image in relief – for inking and subsequent impression to paper. Originally the engraver set out to cut away the non-printing surfaces surrounding the previously drawn lines of the design — careful and laborious work – and this was done with knives and chisels along the grain or plank of the wood in the manner nowadays described as wood cutting. By the second half of the 17th century, if not earlier, the use of boxwood, cut *across* the grain, was well established in the printing trade, particularly for large ornamental initial letters. This hard close-grained wood made possible the use of the metal engraver's tools and with them came a far finer degree of finish. Ralph Beilby had already been working on wood before Bewick was apprenticed and it is likely that he was aware of the end-grain work practised in London. Supplies of the timber were usually bought in the log in London and came up to Newcastle by sea. It was sliced and prepared in the workshop with the aid of a local joiner.

More of the technicalities are given in the captions to the accompanying illustrations, but it should be made plain here that Bewick was not so much the innovator he is so often claimed to be, but rather the reviver and improver of that art. He had no liking for London and so when his fellow townsman

46. A small log of boxwood together with three 'rounds' or slices cut across the grain to a thickness equalling the height of printing type. *T. N. Lawrence & Son.*

47. An untrimmed round of boxwood on which can just be seen the silvery outline of the lead pencil transfer, and the clear white mark of the beginnings of a broad graver stroke clearing the outline. *Iain Bain.*

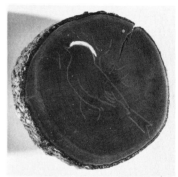

William Bulmer became the leading printer in the city, he deprived himself of the opportunity of getting first class press-work for his own books – though his reluctance to lose the immediate control of his woodblocks is understandable. The Newcastle printers, who were mostly concerned with hasty newspaper production and small jobbing work, had difficulty in the handling of the harder-sized papers and stiffer inks used for fine work, and Bewick was constantly in their press rooms when his own books were in progress.

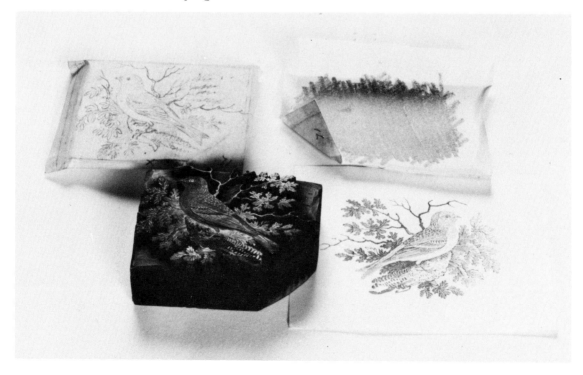

49. Two wood blocks with inked surfaces which demonstrate the greater relative simplicity of cutting a relief surface in 'white line' rather than 'black line,, together with impressions from both blocks. *Iain Bain.*

50. Although Bewick took rough proofs of his wood engravings in his own workshop, the main task of proving and printing them was undertaken by several printers in the town — Thomas Angus, Solomon Hodgson and Edward Walker among them. This 18th-century common- or letter-press is said to have been in Akenhead's printing office on the old Tyne bridge in 1770. The relatively weak construction and action — compared with that of the iron presses invented in the early 19th century — made it impossible to carry a platen that would take off an impression of more than half the area of a full type bed in one pull. *Joicey Museum.*

48. LEFT : A folded drawing (in reproduction) and the same shown with the soft lead of a pencil rubbed across its underside for the process of transfer by sharp-pointed pressure of the outline only; together with Bewick's original block (The Lesser Redpole from his *British Birds*) and a modern impression from the block. *Iain Bain.*

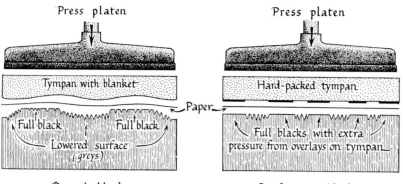

Press platen Press platen

Tympan with blanket Hard-packed tympan

Paper

Full black Full black Full blacks with extra
Lowered surface pressure from overlays on tympan
(greys)

Bewick block Surface-cut block

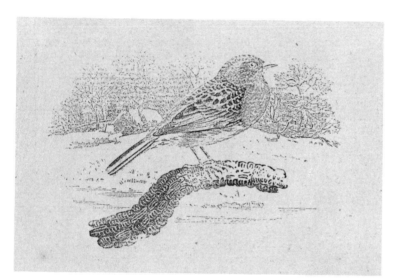

51. A diagram in cross-section showing how the necessary variations in pressure are achieved when printing 'lowered' and 'surface cut' blocks. In the early days of Bewick's engraving the want of precision in the wooden presses then in use, and the uneven surface presented by the often used worn types required a soft spongy impression — achieved by carrying woollen blankets in the press's tympan. To allow for this Bewick lowered those areas of his designs that had to be printed more softly — for example in his distances and in the soft texture of fur and feather, as well as around the edges of his vignetted shapes.

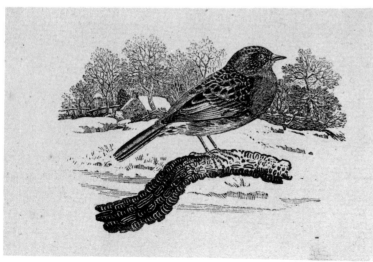

52. Proper conditioning of the paper to be printed was crucial. These two modern impressions taken on 18th-century paper from an original Bewick block, demonstrate the remarkable difference in result when the paper is printed damp: dry paper almost totally rejects the ink on account of the hardness of the size on its surface. In Bewick's books it can often be found that alternate openings are weaker in strength of ink and this is probably accounted for by the drying out of the paper before the back-up impression was taken. *Iain Bain.*

53-68. The following three pages display a variety of jobbing work engraved on wood in Bewick's workshop: Ball tickets, trade cards, tobacco paper cuts, bar bill cuts for inns, and book plates. The engraving immediately below, cut for a Newcastle newspaper is said to have printed over 900,000 impressions. *Trustees of the British Museum.*

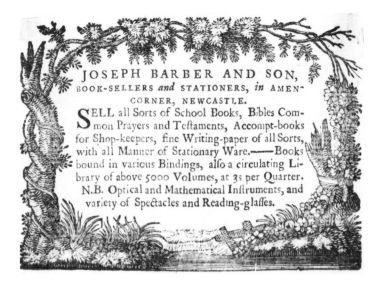

The two engravings (lower left) for the George and Dragon Inn, Penrith, show the development of Bewick's style. The first carries a manuscript note by Jane Bewick, identifying it as the first of her father's blocks to attract attention amongst the local printers.

Engraving and Etching on Copper

In Bewick's apprentice days, a thin plate of copper on which the lines of an image had been recessed below the surface, either by cutting with gravers or by the corrosive action of nitric acid, was considered to be the only medium suitable for producing work demanding any degree of fine detail. But its printing was tedious, slow and relatively expensive, and it was very much a specialist occupation. The printers were usually ininerant journeymen who often brought their own presses with them and they were paid piece-work rates. Because of the workshop's extensive connection with the town and country banks and with the coal factors, there was usually continuous employment for two rolling presses and some of the pressmen stayed with Beilby and Bewick for relatively long periods. George Barber was one of the longest to stay despite his dissolute ways. His output appears to have varied in relation to the amount of ale he consumed – Bewick's vivid record of the man's drinking sprees can be seen in the page from the work book reproduced on page 42. Printing involved the preparation of inks, the inking of the engraved plate to fill the lines of the image, the clean wiping of the surrounding surface with muslins followed by the palm of the hand, and the damping of the paper, before rolling paper and plate through the press under several layers of resilient woollen blankets. The very great pressure of the rolling action moulded the paper into the inked lines. This long process had to be repeated for every impression. The plates required a good deal of maintenance work as the abrasive action of the wiping muslins wore down their surfaces, sometimes after only a few hundred impressions.

Most of the lettering or 'writing' engraving, in which Bewick was particularly skilled, was cut with gravers. The use of the curved leather-covered block on which the plate was placed was particularly important for the cutting of curved lines where

69. Bewick's bill-head during the time of his partnership with his son Robert (1812-1825): it shows that metal engraving and copper-plate printing were still the staple of the business. *Iain Bain.*

70. A wooden rolling press of 18th-century construction, but with an added 19th-century gearing. Bewick had two such presses in his workshop. *Science Museum, London.*

much of the action came from swinging the plate into the point of the graver. Corrections were made by burnishing the surface, having first knocked it up with punches from below; calipers were used for the accurate marking of the position to be treated.

Much of the pictorial work, such as the coach and horses on the plate shown on page 42, was etched with acid after drawing with a needle to bare the metal through a previously prepared acid-resisting 'ground' usually made up from asphaltum, burgundy pitch and white wax. The use of a needle gave the artist a rather greater freedom in handling. A certain amount of book illustration on copper came through the workshop, one of the principal works being a locally published edition of the Bible in which there was a mixture of engraving and etching.

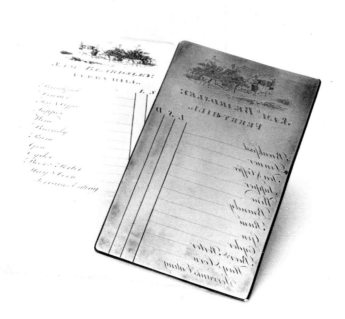

71. An original copper-plate and a modern impression. Engraved for Samuel Beardsley, inn-keeper of Ferryhill, 1803. *Iain Bain.*

74-75. RIGHT: Notes engraved for the Durham and Carlisle Banks. *Trustees of the British Museum.*

72-73. Pages from the workshop records relating to copper-plate printing and the wages of one of the press-men George Barber. *Laing Gallery.*

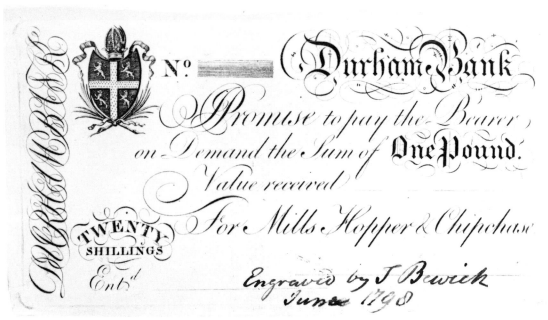

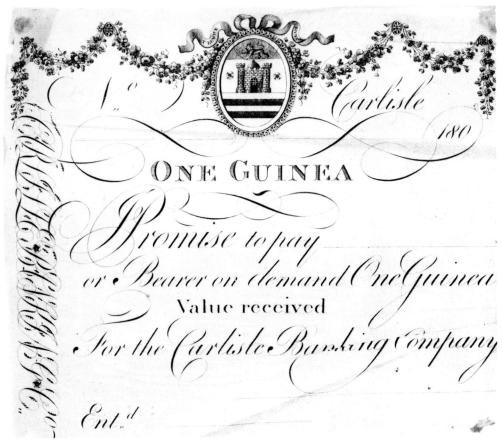

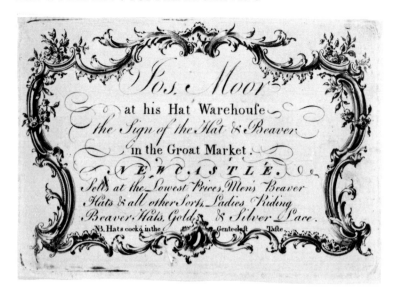

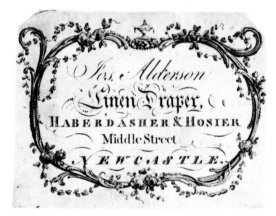

76-84. These two pages display a variety of jobbing work engraved on copper in Bewick's workshop: trade cards, labels, bookplates and (TOP RIGHT) an impression from a plate engraved for printing pottery transfers. *Trustees of the British Museum.*

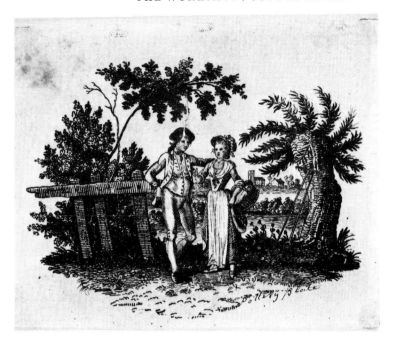

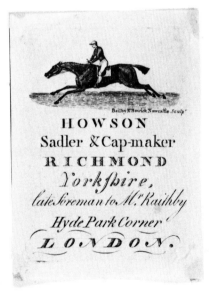

It is interesting to observe that much of Bewick's pictorial work on copper achieves an effect which he made in wood engraving by an exactly opposite approach though using the same linear conventions, the one working on the creation of white lines out of a black ground, the other on black lines from a white ground.

Engraving and Etching on Silver

The records show that an extraordinary volume of silver engraving was handled in the workshop, particularly for the Newcastle business of Langlands and the later partnership of Langlands & Robertson, although the names of at least thirty other silversmiths appear. As for engraving on wood and copper, the points and shapes of the tools were prepared for particular purposes; in some cases the stems would be bent or 'bellied' to prevent their points digging into the metal. The bellied shape was particularly useful when working on the inside of curved surfaces – for example when mottoes were being cut on the inside of rings. Special 'bright work' which became fashionable in the latter half of the 18th century and which had much sparkle in it, was achieved by cutting with the graver held tilted to one side so as to create a v-shaped groove with one wall a good deal larger than the other.

For pictorial work, such as the hunting scene on the salver shown below, the image was etched with acid as for similar work on copper. The acid could be applied locally by building up a wall of bordering wax round the image. The writing engraving seems without exception to have been cut rather than etched.

Designs could be drawn on the surface of the silver once it had been painted – or waxed and then powdered – with white chalk. A small pointed wooden stick was used to 'point in' the lines, followed by a steel needle to make a very light mark in the metal once the design was reckoned to be satisfactory. The

86. RIGHT: Silver Cake Basket, engraved by Bewick with a ship in flames and inscribed: 'A gift from the Unanimous and Equitable Associated Underwriters to Nichs. Fairles, Esqr. for his intrepid Conduct and animating example shown in extinguishing a fire on board the ship *Joseph and Mary* at South Shields on the 7th Sept, 1798'. Made by Langlands and Robertson, Newcastle. The workshop account book for the period records a charge of 15 shillings for the engraving. *Lloyds of London.*

87. LOWER RIGHT: Gold 'Freedom' Box, presented to the Hon. Augustus Keppel, Admiral of the Blue, by the Corporation of Trinity House, Newcastle upon Tyne in 1779. Made by Langlands and Robertson of Newcastle. The workshop records show a charge of 2 guineas for the engraving on 29 March 1779. Keppel achieved a national popularity following his acquittal from a court martial in February 1779 where it had been alleged that he had been guilty of gross misconduct during an encounter with the French fleet in 1778. *Laing Gallery.*

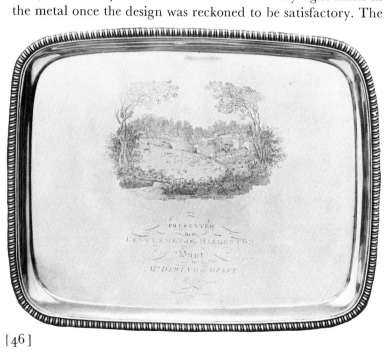

85. Silver Salver, engraved by Bewick with a hunting scene and inscribed: 'Presented by the Gentlemen of the Harleston Hunt to Mr. Dewing of Guist, March 1808'. Made by Ann Robertson, Newcastle 1808. The Weekly Engraving Book for the period records the charge of £3.13.6d. on 22 August 1808. *Victoria and Albert Museum.*

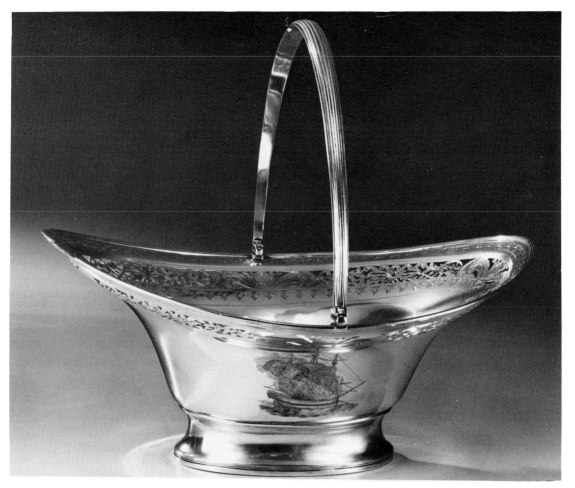

chalk could then be wiped off. The template of the running hare shown on page 48 demonstrates an additional aid to getting accurate proportions on to a curved surface.

Bewick's correspondence shows evidence of a number of commissions from the country gentry, and on one occasion in

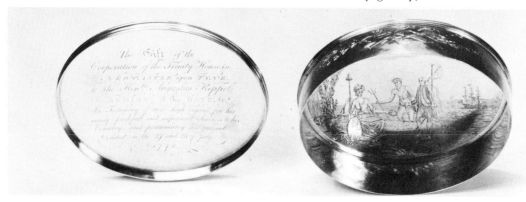

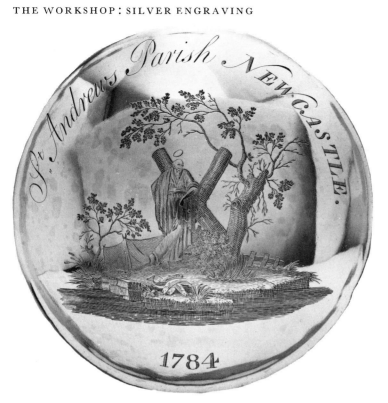

88. Silver Alms Dish, engraved in the workshop with the figure of St Andrew to an original design of 1776. Made by Pinkney and Scott, Newcastle, 1787-8. *Laing Gallery.*

1800 he was asked to send one of his men to the customer's house: '– It would be inconvenient to me to send the plate to NCastle as being so much of it now unpacked. The principal thing to be engraved is my Crest. 8 Doz knives and Forks, Spoons, – Cruets – & 2 Salvers with Arms, Tea Pots &c which would take a man no more than a Fortnight, & as I would pay his Journey here and Back – I cannot see the objection to his Working here, as well as at N Castle . . .'.

89. Template of a running hare, cut for the accurate transfer of the outline to a curved surface in preparation for engraving. The motto to be engraved can be seen lightly pencilled at the foot of the sheet. *Iain Bain.*

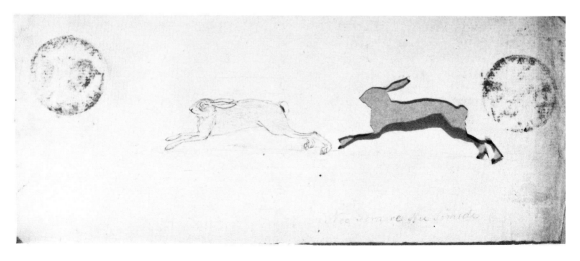

90-96. A group of impressions from engraved silver handled in the workshop. *Trustees of the British Museum.*

Engraving for Book Production

Early Work

Although Bewick engraved on wood for a fair quantity of ephemeral jobs, he is principally remembered as an illustrator of books. The first batch of such work was for Hutton's *Mensuration* which began publication in parts in 1768 and for which the first blocks were cut in the fifth week of Bewick's apprenticeship which had begun in October of the previous year. It is said that he was soon at work on the project. Although very few of the blocks had any pictorial content, the majority being linear geometrical diagrams, the book is interesting for the account given by its author of his contact with the workshop, which he contributed to the *Monthly Magazine* in 1822: '. . . As that work was to be printed in Newcastle, where I had resided since 1760, it became necessary, or convenient, to have executed there the numerous wooden diagrams which occur in the work . . . There was not then in that part of the country any artist who had ever seen such engraving executed. But as I had, in the course of several visits which I had made to London, seen there the manner of such operations, and made myself well acquainted with it, I conceived the idea of making Mr R. Beilby the means of executing the diagrams, with whom the ingenious Mr Thos. Bewick was then apprentice. – Accordingly, I procured the necessary blocks of box-wood from London, with the tools proper for cutting or carving on them, instructing those persons how to cut out and square the blocks, and to cut or engrave on the smooth face of them the necessary lines and letters in the diagrams, by which, in frequently attending them for their instruction, we got the cuts tolerably well executed . . .'. It seems unlikely that anyone so practical in many branches of engraving as Beilby, would have been entirely ignorant of the practice of the London engravers, but nevertheless Hutton was probably responsible for providing serious encouragement.

A coincidence of Beilby's seeming dislike of working on wood and perhaps Bewick's affinity for the subject matter, soon found the apprentice at work on a number of children's books – principally for Thomas Saint the printer of Hutton's *Mensuration*: before Saint's death in 1788 he had cut illustrations for at least thirty-five titles such as, for example, *Tommy Trip's History of Birds and Beasts*, *Little Red Riding Hood*, *Tommy Tag's Poems* and *Goody Two Shoes*. All are recorded in the workshop ledgers but the books themselves are now difficult to find.

97-98. Two engravings by Bewick for the story of Cinderella which appear in Saint's *New Year's Gift* of 1777 but which may have been used at an earlier date. *Trustees of the British Museum.*

102. OPPOSITE LEFT: *The only Method to make Reading Easy, or Child's Best Instructor; Containing Emblematic Cuts for the Alphabet . . .* by T. Hastie, Schoolmaster, Newcastle, n.d. A text page from one of Bewick's earliest commissions. *Trustees of the British Museum.*

[50]

99-100 Title and text page from Hutto 's *Treatise on Mensuration*, which began publication in parts in 1768. *Laing Gallery.*

103. BELOW RIGHT: *Fables by the late Mr. Gay . . .* printed by and for T. Saint, Newcastle, 1779: the page showing the well-known subject 'The Hound and Huntsman' for which Bewick was awarded a premium by the Society for the Encouragement of Arts in 1776. *Pease Collection.*

A

TREATISE

ON

MENSURATION,

BOTH IN

THEORY and PRACTICE.

By CHARLES HUTTON.

NEWCASTLE UPON TYNE:

Printed by T. SAINT for the AUTHOR, and for JOHN WILKIE in St Paul's Church Yard, and RICHARD BALDWIN in Pater-noster Row, London. 1770.

42 HEIGHTS *and* DISTANCES. Part I.

EXAMPLE X.

From a window near the bottom of a house, which seemed to be upon a level with the bottom of a steeple, I took the angle of elevation of the top of the steeple equal 40°, and from another window 18 feet directly above the former, the same angle was 37° 30′: What then is the height and distance of the steeple?

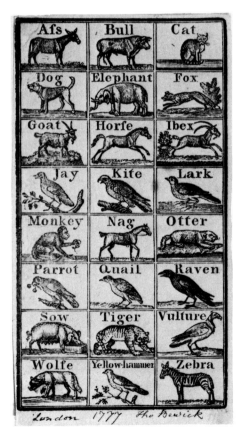

132 F A B L E S.

FABLE XLIV.

The HOUND *and the* HUNTSMAN.

Impertinence at first is borne
 With heedless flight, or smiles of scorn;
Teaz'd into wrath, what patience bears
The noisy fool who perseveres?
 The morning wakes, the Huntsman sounds,
At once rush forth the joyful hounds.
They seek the wood with eager pace,
Through bush, through brier, explore the chace:
Now scatter'd wide, they try the plain,
And snuff the dewy turf in vain.

 What

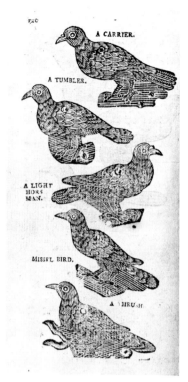

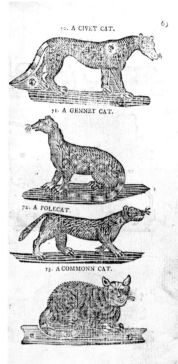

104. *A Description of Three Hundred Animals*, [by Thomas Boreman], 10th edition, 1773. It is not difficult to see why this book inspired Bewick to think he could do better: the engravings are crudely cut in 'white line' on metal plates; they show the nail heads struck roughly into the face of the image where they were fixed to mounts for printing with type. *Iain Bain.*

The *General History of Quadrupeds*

In November 1781, four years after the beginning of his partnership with Beilby, Bewick wrote a letter to Squire Fenwick of Bywell asking him for information about his horse Matchem: 'An anxious desire for information has prompted me to take the liberty of troubling you with these few lines . . . – We intend in a little time, to publish a natural History of Quadrupeds, and as the Horse, is the first which we shall begin with, we wish to relate as many authentic Anecdotes as may be thought curious, of that noble Animal . . .' Predating by four years Bewick's own record of the start of his preparations for engraving, the letter reinforces other evidence relating to his considerable contribution to the text. In his *Memoir* he wrote: 'Having from the time that I was a school Boy, been displeased with most of the cuts in children's books, & particularly with those of the "Three hundred Animals" the figures of which, even at

that time, I thought I could depicture much better than those in that Book; and having afterwards, very often turned the matter over in my mind, of making improvements in that publication – I at last came to the determination of commencing the attempt. The extreme interest I had always felt in the hope of administering to the pleasures & amusement of youth & judging from the feelings I had experienced myself that they would be affected in the same way as I had been, this whetted me up & stimulated me to proceed – '. The time was ripe for the publication of the *Quadrupeds* in 1790: Gilbert White's classic *Natural History of Selborne* had appeared in the previous year and popular interest in the subject was increasing rapidly. The truth and liveliness in Bewick's portrayal of many of the animals – often set in minutely observed backgrounds – brought a freshness to this class of book that was entirely new.

105. An early prospectus for the *History of Quadrupeds*, dated 2 April 1788, two years before publication. *Iain Bain*.

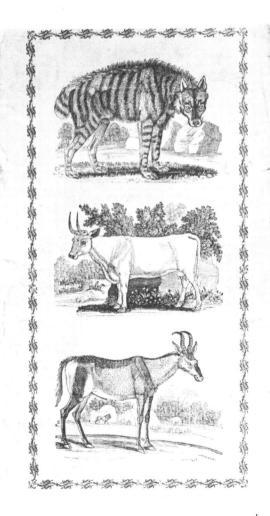

A GENERAL

HISTORY

OF

QUADRUPEDS.

THE FIGURES ENGRAVED ON WOOD BY T. BEWICK.

NEWCASTLE UPON TYNE:

PRINTED BY AND FOR S. HODGSON, R. BEILBY, & T. BEWICK, NEWCASTLE: SOLD BY THEM, BY G. G. J. & J. ROBINSON, AND C. DILLY, LONDON.

1790.

106-107. The title-page and an opening from the first edition of the *General History of Quadrupeds,* 1790.

314 HISTORY OF QUADRUPEDS.

THE SPANISH POINTER

is of foreign origin, as its name seems to imply; but it is now naturalized in this country, which has long been famous for Dogs of this kind; the greatest attention being paid to preserve the breed in its utmost purity.

This Dog is remarkable for the aptness and facility with which it receives instruction: It may be said to be almost self-taught; whilst the English Pointer requires the greatest care and attention in breaking and training to the sport. The Spanish Pointer, however, is not so durable and hardy, nor so able to undergo the fatigues of an extensive range. It is chiefly employed in finding partridges, pheasants, &c. either for the gun or the net.

It is said, that an English nobleman (Robert Dudley, duke of Northumberland) was the first that broke a Setting-Dog to the net.

Many of the Setting-Dogs, now used by sportsmen, are a mixt breed, between the English and Spanish Pointer.

THE

HISTORY OF QUADRUPEDS. 315

THE NEW SOUTH-WALES DOG

is of a very savage nature. It neither barks nor growls; but when vexed, erects the hairs of its whole body like bristles, and appears extremely furious.—It is fond of rabbits and chickens, which it eagerly devours raw; but will not touch dressed meat.——Its great agility gives it much the advantage over other animals superior in size. One of them, sent to this country from *Botany-Bay,* was so extremely fierce, as to seize on every animal it saw; and, if not restrained, would have run down Deer and Sheep: An Ass had also nearly fallen a victim to its fury.

The height of this species is rather less than two feet; the length two feet and a half. The head is formed much like that of a Fox; the ears short and erect. The general colour is a pale-brown, lighter on the belly; the feet and inside of the legs white. The tail is rather long and bushy, somewhat like that of a Fox.

We

For the NEWCASTLE ADVERTISER.

To Mr T. BEWICK,

On his excellent Engravings on Wood, in the HISTORY of QUADRUPEDS, published at Newcastle.

GO on great Artist in thy pleasing way,
And learn us Nature as the rising day!
Thy just Creator's wond'rous beings show,
And teach us from thy art—his boundless pow'r to know:
Thy charming pencil claims our warm applause,
And leads us on to study Nature's laws.

Though distant climes produce a savage race,
And Britain's realms present their beasts of chace,
At home we sit—peruse thy well-form'd plan,
And vindicate the ways of God to man!
Charm'd with the subject, we the theme pursue,
Nor yet forget our thanks are due to you.

Oh! at some future period may thy breast,
With other pleasing subjects be imprest:
Pourtray the warbling songsters of the woods,
The scaly tribe that range the briny floods;
Depict the reptile, and the insect race,
In well-wrought lines, drawn with thy usual grace;
So shall we in this field of wonder find,
An art discover'd, and an end design'd.

GEO. BYLES.

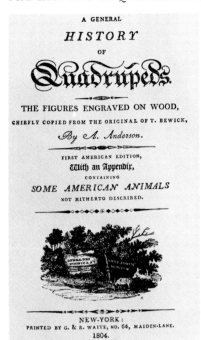

108. An admiring poem written for the *Newcastle Advertiser* by George Byles on the publication of the *History of Quadrupeds* in 1790.

109. TOP RIGHT: An edition of the *Quadrupeds* published in New York in 1804, with engravings copied directly from Bewick's work by Alexander Anderson who trained and practised as a physician and was at the same time the father of wood engraving in America.

110-119. A selection of engravings from the *History of Quadrupeds.* (continued overleaf)

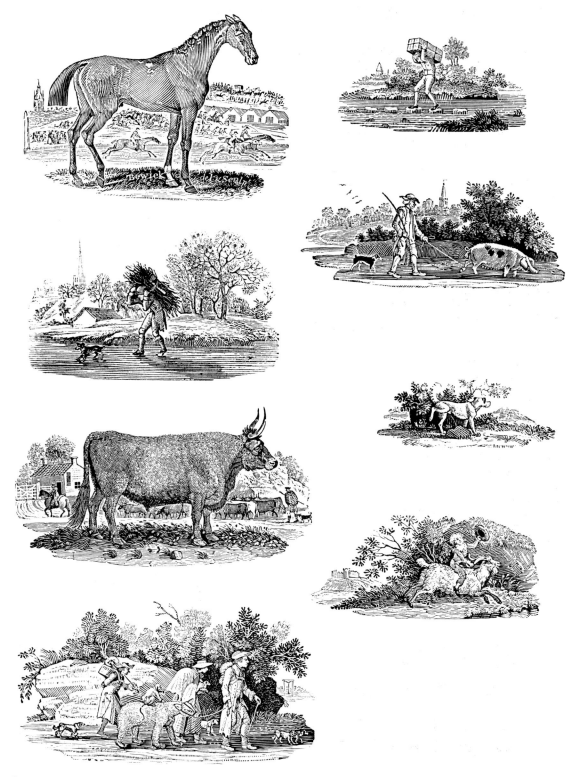

The *History of British Birds*

The *Quadrupeds* had not been long published before Bewick was getting enquiries about the possibility of a companion work on birds. By 1791 he had set out to Wycliffe in North Yorkshire to spend two months drawing from stuffed specimens in Marmaduke Tunstall's private museum. At that stage a 'General History' was planned but after drawing a quantity of foreign species it was soon found that such a task was too great, and the plan was limited to the birds of Britain. Many sources were plundered for the compilation of the text, though as with the *Quadrupeds*, Bewick's observations on the habits of the creatures he knew well himself added a good deal of originality to the book. Again, as it was with the *Quadrupeds*, the engraving of the blocks was confined to the evenings, after the day's work in the

120-121. Two of the sources Bewick employed for the compilation of the text of the *History of British Birds*: LEFT: *The Ornithology of Francis Willughby . . .*, 1678. *Natural History Society of Northumbria;* RIGHT: *L'Histoire de la Nature des Oyseaux*, Pierre Belon, Paris, 1555. *Natural History Society of Northumbria.*

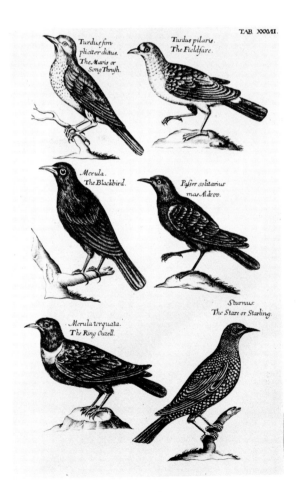

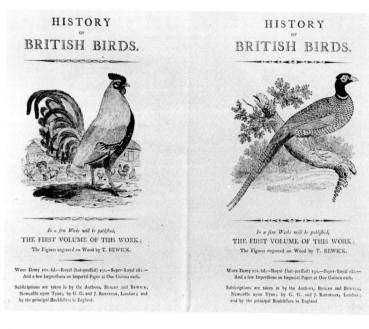

122. The prospectus for the *History of British Birds*, 1797, announcing the publication of the first volume, 'Land Birds'; printed as a pair and preserved in original state before trimming. *Iain Bain.*

shop was over. Two volumes were published, 'Land Birds' in 1797 and 'Water Birds' in 1804. The public reception was even more enthusiastic and the *Birds* soon became the best loved of Bewick's books. The tail-pieces excited particular delight, and in these he now had much assistance from his apprentices.

123-124. The title-page and an opening from the first edition of the *History of British Birds*: Land Birds, 1797.

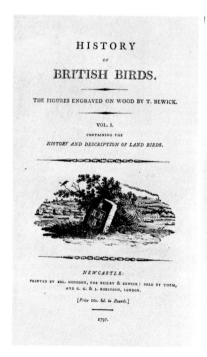

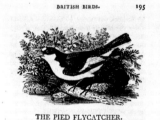

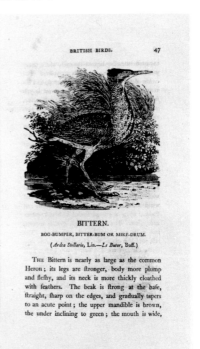

125-126. The title-page and an opening from the first edition of the *History of British Birds*: Water Birds, 1804.

127. *An History of the Earth, and Animated Nature*, by Oliver Goldsmith, 1791. This engraving on copper — by Isaac Taylor, who gave Bewick employment during his brief stay in London — gives some idea of how startlingly fresh Bewick's work would have appeared when first published. *Iain Bain.*

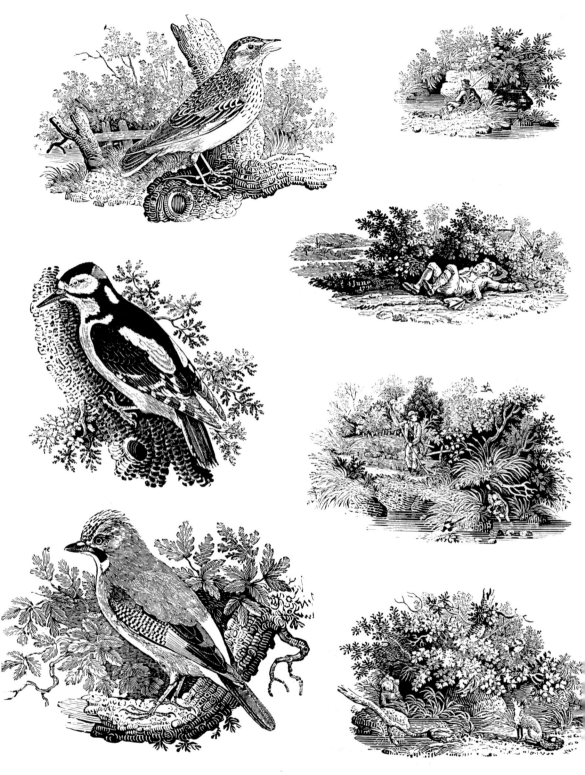

128-137. A selection of engravings
from the *History of British Birds*.

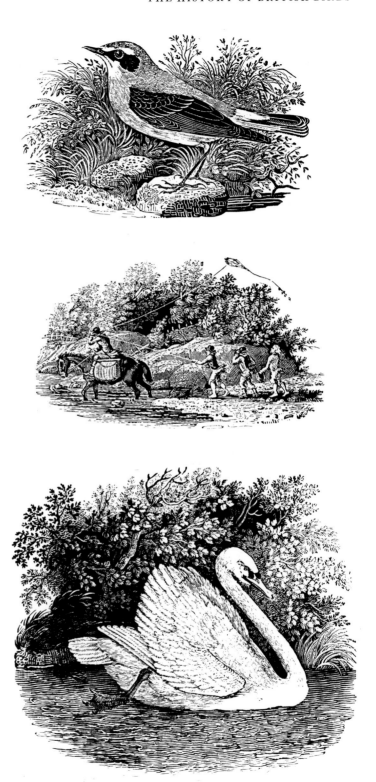

The Fables of Aesop

For the last completed work of his own publishing, Bewick took up his long interest in fables and moral tales which had been so much a part of his boyhood reading. In his *Memoir* he wrote: 'During a severe illness, with which I was visited in April 1812 ... I could not help regretting that I had not published a Book, similar to "Croxalls Esops Fables" ... I thought with better executed designs, it would impart the same delight to others, that I had experienced from attentively reading it. . . . As soon as I was so far recovered as to be able to sit at the window at

THE

FABLES OF ÆSOP,

AND OTHERS,

WITH DESIGNS ON WOOD,

BY

THOMAS BEWICK.

" *The wisest of the Ancients delivered their Conceptions of the Deity, and their Lessons of Morality, in Fables and Parables.*"

NEWCASTLE:

PRINTED BY E. WALKER, FOR T. BEWICK AND SON.
SOLD BY THEM, LONGMAN AND CO. LONDON,
AND ALL BOOKSELLERS.

1818.

138. The title-page from *The Fables of Aesop*, 1818.

home, I immediately begun to draw designs upon the wood, of the Fables & vignettes, and to me this was a most delightfull task – In impatiently pushing forward to get to press with the publication, I availed myself of the help of my pupils (my son, Wm Harvey & Wm Temple). . . . I found in this Book more difficulties than I had experienced with either the Quadrupeds or the Birds.' The part played by the apprentices is most interestingly illuminated in a letter Bewick wrote to his old friend Robert Pollard in 1816: '. . . during the day I am employed in designing & drawing the subjects on the wood – & this is rather a laborious kind of work – I am obliged [to finish] the drawing with miniature like minutia, otherwise my Boys cou'd not cut them – this also requires my close superintendance & help and when the Cuts are done I then go over the whole.' The hard-sized paper gave the printers a good deal of trouble and the indifferent impressions found in many copies of the two editions has tended to obscure the very great merit of many of the engravings.

139. The receipt plate from the *Fables of Aesop* : as an aid to preventing the loss of copies from printing house and warehouse, Bewick issued this receipt with every copy. Two impressions were made, from engraved copper and from wood.

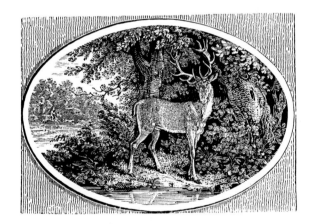

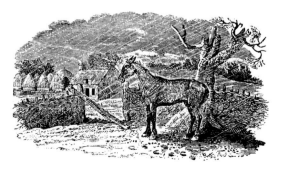

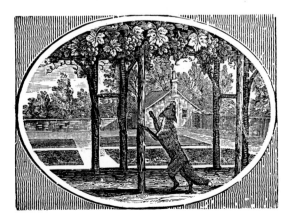

140-148. A selection of engravings from the *Fables of Aesop*. The two tail-pieces immediately above are quite opposite in manner to the usual 'white-line' work. They were described in the workshop records as 'pen & ink facsim', clearly confirming them to be precise cuttings of finished drawings made directly on the wood.

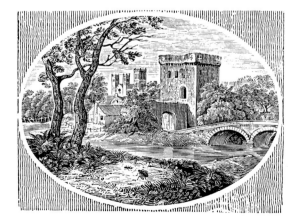

A
HISTORY
OF
BRITISH FISHES.
THE FIGURES ENGRAVED ON WOOD,
BY T. BEWICK.
This Work is intended to be put to Press in 1826,
AND TO BE
PRINTED ON IMPERIAL, ROYAL, AND DEMY PAPERS,
TO MATCH THE HISTORIES OF QUADRUPEDS, AND BRITISH BIRDS,
AND THE FABLES OF ÆSOP.

Subscriptions
RECEIVED BY ALL BOOKSELLERS, AND BY
T. BEWICK AND SON, NEWCASTLE.

149. A prospectus for the *History of British Fishes. Iain Bain.*

150. A preliminary drawing for one of the few subjects engraved for the *History of British Fishes*, $4 \times 5\frac{1}{4}$ in. *Natural History Society of Northumbria.*

The *History of British Fishes*

For so keen an angler, it is not surprising that Bewick, after the completion of the *Fables*, set about producing a history of British fishes. He also saw in it a means of establishing his son's reputation as an engraver. Prospectuses were issued announcing that the work would be put to press in 1826, but unfortunately the combination of Bewick's old age and failing powers, the difficulty of procuring good specimens, and Robert Bewick's gentle diffidence was too much and the publication was never achieved. About sixteen subjects were engraved, some of them remarkably fine, and preparatory drawings by Robert for about a hundred more were in readiness. Forty or fifty tail-pieces were engraved and eventually used in the two post-humous editions of the *British Birds*. A certain amount of manuscript for the text survives, put together with help from correspondents such as Jonathan Couch of Polperro, who was some years later to publish his own work illustrated with colour plates. It was William Yarrell who eventually put out a two-volume *History of British Fishes* in 1836. Bewick knew him and they had met in 1828 on Bewick's second and last visit to London. In his introduction Yarrell acknowledged Bewick's skill and said that he would never have attempted his own work had 'any such intention still existed in Newcastle'. It is interesting to compare the style of the engravings in Yarrell's book, some of which were by Henry White a former apprentice in Bewick's workshop. An altogether harder and finer finish prevails and the tail-pieces are quite without narrative content.

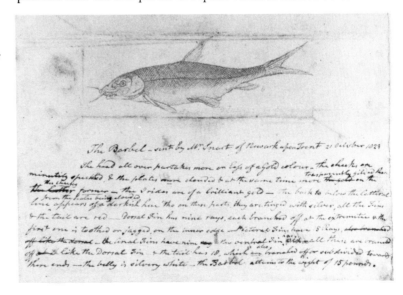

151-155. A selection of some of th e few engravings prepared for the *History of British Fishes*.

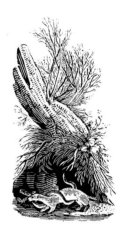

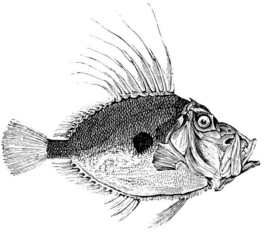

Work for Other Publishers

The success of Bewick's *Quadrupeds* secured him the wider reputation that brought him contact with many printers and publishers throughout the country, who began to see the commercial advantage in having his name on their title-pages. The most celebrated relationship was formed with his fellow townsman William Bulmer by then working in London. The two quarto books for which Bulmer commissioned engravings, *Poems by Goldsmith and Parnell*, 1795, and Somervile's *The Chase*, 1796, set out specifically to 'raise the Art of Printing' and in his Advertisement to the *Goldsmith* Bulmer wrote: 'The ornaments are all engraved on blocks of wood, by two of my earliest acquaintances, Messrs. Bewicks, of Newcastle upon Tyne and London, . . . They have been executed with great care, and I may venture to say . . . that they form the most extraordinary effort of the art of engraving on wood, that ever was produced in any age, or any country . . .'. Unfortunately Bewick came to feel that he was being exploited: although he had agreed to a specific fee for the *Goldsmith*, when he compared Bulmer's turnover of more than £1000 with the £37.7s. he had for the blocks he felt hard done by, and by 1802 he was

156. *A Tour through Sweden, Swedish-Lapland, Finland and Denmark*, by Matthew Consett, Stockton, 1789. One of the few works for which Bewick engraved on copper. The illustrations show how much less happy he was in this medium and when working on a larger scale. *Laing Gallery.*

157-158. The title-page and an opening from *Poems by Goldsmith and Parnell*, printed by William Bulmer at the Shakspeare Press, 1795. *Laing Gallery.*

159-160. The title-page and a page of text from *The Chase* by William Somervile, printed by William Bulmer at the Shakspeare Press, 1796. *Laing Gallery.*

161-163. The title-page, some of the translator's manuscript notes and sketches, and an engraving from Le Grand's *Fabliaux or Tales*, 1796 and 1800. A fine example of a privately financed and published book. Gregory Way, the translator, was encouraged by Bulmer to employ Bewick and his brother John. *Iain Bain and David Chambers.*

refusing to consider any further work for Bulmer. Had Bewick not been so fully committed to serving the trades and industries of Newcastle as a metal engraver, he might well have contributed a great deal more to the world of fine printing that flourished in the years of his prime.

For some books Bewick engraved the designs of Thurston and Craig; for some he engraved in a fashion too fine for the capacity of their printers; often he found it difficult to meet with speed the commissions from further afield – much was refused or else given to the apprentices.

THE

POETICAL WORKS

OF

OLIVER GOLDSMITH, M.B.

COMPLETE IN ONE VOLUME.

WITH

THE LIFE OF THE AUTHOR.

THE VIGNETTES
DESIGNED, AND ENGRAVED ON WOOD,
BY T. BEWICK.

" And all the village train, from labour free,
" Led up their sports beneath the spreading tree"—
DES. VIL. P. 44.

HEREFORD:
PRINTED BY D. WALKER,
AT THE OFFICE OF THE HEREFORD JOURNAL,
IN THE HIGH-TOWN.

1794.

164. *The Poetical Works of Oliver Goldsmith*, D. Walker, Hereford, 1794. A book typical of many commissions received by Bewick from provincial printers, who saw his name as an aid to sales. The engravings appear to have some trace of apprentice work in them. *Iain Bain.*

166. RIGHT: *The Hermit of Warkworth. A Northumberland Ballad* by Dr. Thomas Percy, J. Catnach, Alnwick, 1805. One of many commissions from Alnwick. The title gives prominent display to Bewick's name though on this occasion he worked in a reproductive capacity after the original drawings by W. M. Craig.

POEMS.

TAM O' SHANTER.

A TALE.

Of Brownyis and of Bogillis full is this Buke.
GAWIN DOUGLAS.

WHEN chapman billies leave the street,
And drouthy neebors, neebors meet,
As market-days are wearing late,
An' folk begin to tak the gate;
While we sit bousing at the nappy,
An' getting fou and unco happy,
We think na on the lang Scotch miles,
The mosses, waters, slaps and styles,
That lie between us and our hame,
Whare sits the sulky sullen dame,
Gath'ring her brows like gath'ring storm,
Nursing her wrath to keep it warm.

This truth fand honest *Tam o' Shanter,*
As he frae Ayr ae night did canter,
(Auld Ayr wham ne'er a town surpasses,
For honest men and bonny lasses.)

165. *The Poetical Works of Robert Burns . . . Engravings on wood by Thomas Bewick*, Alnwick, W. Davison, 1808. A workshop job with contributions from Edward Willis and Henry White — both apprentices at the time. *Iain Bain.*

Enough for us to know that this dark state,
In wayward passions lost, and vain pursuits,
This infancy of being, cannot prove
The final issue of the works of God,
By boundless love and perfect wisdom form'd,
And ever rising with the rising mind.

THE

HERMIT OF WARKWORTH.

FIT III.

One early morn, while dewy drops
Hung trembling on the tree,
Sir Bertram from his sick bed rose,
His bride he would go see.

........... Check'd, at last,
By love's respectful modesty, he deem'd
The theft profane, if aught profane to love
Can e'er be deem'd; and, struggling from the shade,
With headlong hurry fled..........

167. ABOVE RIGHT: *The Seasons, by J. Thomson. Embellished with Engravings on Wood by Bewick, from Thurston's Designs*, James Wallis, 1805. Thurston was a north-countryman who established himself as the principal draughts-man on wood for the London engraving trade. Bewick had to work on several jobs under his direction. *Iain Bain.*

168. *The Hive of Ancient and Modern Literature . . . Selected by the Late Sol. Hodgson*, 4th edition, 1812. First published in 1799, the number of engravings was increased in later editions, some by Bewick himself and others by his apprentice Luke Clennell who took on the completion of the work following the prolonged delays of his master. One of Bewick's own engravings is reproduced here. *Pease Collection.*

A

NEW

FAMILY HERBAL:

OR

POPULAR ACCOUNT

OF

THE NATURES AND PROPERTIES

OF THE VARIOUS

PLANTS

USED IN

MEDICINE, DIET, AND THE ARTS.

BY

ROBERT JOHN THORNTON, M.D.

LECTURER ON BOTANY AT GUY'S HOSPITAL, &c. &c.

THE PLANTS DRAWN FROM NATURE,
BY HENDERSON:

AND ENGRAVED ON WOOD,

BY THOMAS BEWICK.

London:

PRINTED FOR RICHARD PHILLIPS,

BRIDGE-STREET, BLACKFRIARS;

AND MAY BE HAD OF ALL BOOKSELLERS.

1810.

DOG ROSE.
ROSA CANINA.

169-170 *A New Family Herbal* . . . by Robert John Thornton, M.D., Richard Phillips, 1810. The drawings were prepared by J. Henderson and engraved by Bewick's apprentices — their names are recorded in several cases in the workshop engraving books, Henry White, Isaac Nicholson and John Bewick (nephew) among them. *Pease Collection.*

174-175. RIGHT : Two wrapper engravings by Bewick cut for T. Hodgson during Bewick's short stay in London, 1777. *Trustees of the British Museum.*

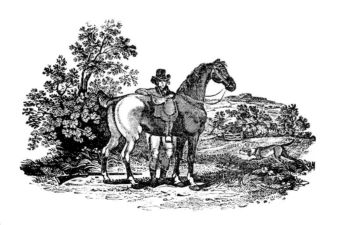

171. *The Sportsman's Cabinet ; or a Correct Delineation of the Canine Race* . . .1803. Two quarto volumes, with copper engravings by John Scott, and tail-piece wood engravings from Bewick's workshop and others by the London engraver Richard Austin. The cut reproduced here was charged at £1.11.6d. and was probably engraved by Luke Clennell. *Pease Collection.*

The Development of Bewick's Engraving Style

It is interesting to observe that the vignette form which Bewick made so much his own was already part of the idiom in which the Beilby family worked when he joined the workshop; a number of their enamelled glasses carry small landscape vignettes, and Ralph Beilby was engraving similarly on copper for bookplates. We know that Bewick owned books of fables from the earlier part of the century which had engravings in the white-line manner he himself adopted. Some of the work of Elisha Kirkall the probable engraver of Croxall's *Aesop's Fables* in 1722 is particularly good and it is difficult to believe that it was unknown to Bewick.

The influence of William Woollett, one of the most successful of 18th century engravers on copper is also clear: his 'Spanish Pointer' after Stubbs hung in Bewick's parlour for many years. The handling of foliage and tree bark in the 'Chillingham Bull' is strongly reminiscent – though where the copper engraver cut for recessed black lines, Bewick engraved lines on his relief surface to print as white. Although Bewick seems to have found a strongly individual style early, a change in his manner and skill can be seen in the selection of his engravings shown here.

172-173. Two engravings for *Red Riding Hood* in Bewick's earliest manner. *Trustees of the British Museum.*

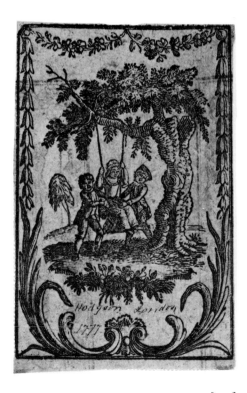

176. A tail-piece from the *History of Quadrupeds*, 1790, still reflecting Bewick's earlier manner and with the vignette form still slightly stiff in outline.

177-178. Two tail-pieces from the *History of British Birds*, 1797-1804, in which Bewick's style can be seen in its most mature form.

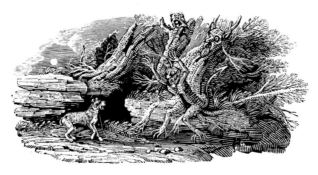

179. A later tail-piece for the *History of British Birds* engraved in 1827 and in progress when Bewick was visited by the American artist and naturalist John James Audubon. It displays a looser, more linear manner.

The Narrative Tail-piece Vignettes

Bewick's liking for the moral tale and his long familiarity with the popular 18th century books of fables gave him the stimulus to create these diversions for the younger readers of his natural histories: 'When I first undertook my labours in Natural History my strongest motive was to lead the minds of youth to the study of that delightful pursuit . . . and as instruction is of little avail without constant cheerfulness and occasional amusement I interspersed the more serious studies with *Tale*-pieces of gaiety and humour; yet even in these seldom without an endeavour to illustrate some truth or point some moral'. For many of his admirers tail-pieces held as much charm as his figures of birds and animals; their content is not always obvious for Bewick was sometimes deliberately enigmatic in order to provoke speculation and thought. Every subject is worthy of minute scrutiny for sometimes the smallest detail can supply a vital clue to its meaning. Some examples are shown here with explanatory notes taken from a manuscript compiled for the purpose by Jane Bewick.

180. 'How can ye expect the bairns will be honest when the mother's a thief': a pencilled note in Bewick's hand on a proof. *Iain Bain.*

181. The man is blind, the ignorant boy cannot read, but on the first stepping-stone the dog instinctively knows the way across.

192. 'Saving the toll': the cow presses on; her driver hesitates — hearing warnings from the opposite bank; he loses his hat — worth more than the toll he would have paid to cross by the bridge.

183. Instinct teaches the two animals to walk wisely — Churches and sign-boards do not avail in teaching men to keep in the right path.

184. The hen has brought out four ducklings. The old proverb says 'If you put another man's child in your bosom, it will creep out at your sleeve'.

185. From the head of the Preface to the second volume of the *History of British Birds*: 'Neither a grace nor a preface should be too long' — a gibe at false piety.

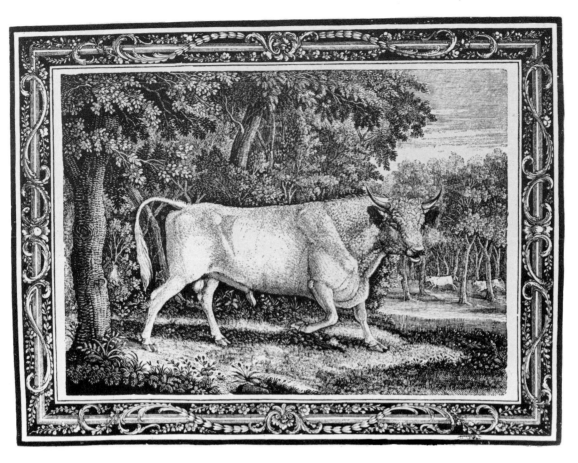

186. 'The Chillingham Bull', 1789. Bewick's celebrated engraving commissioned by Marmaduke Tunstall of Wycliffe in North Yorkshire, for which he was charged 7 guineas. Reduced from $7\frac{1}{4} \times 9\frac{3}{4}$ in. *Pease Collection.*

The Larger Single Prints

The 'Chillingham Bull' is the best known of Bewick's larger engravings and certainly the most successful of them. Formal and decorative, it is strongly influenced by the conventions of the copper engraver and was no doubt in part an attempt to improve the general regard for wood engraving. It has attracted considerable attention from collectors' almost philatelic obsession with early and later states, the rarer early states being the more desirable since the block opened up along the join of the two largest of its three sections soon after the first impressions were taken. The other larger and similarly formal print 'Waiting for Death' is far from successful, though full of feeling. The several prints of lions, tigers and elephants engraved for Pidcock and Polito the menagerie proprietors have a vigorous directness suited to their purpose, but neither these

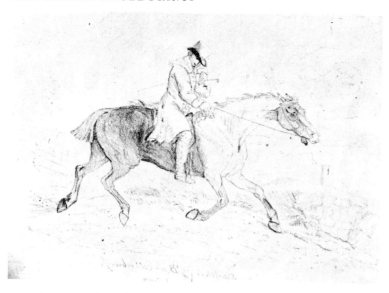

187. 'The Cadger's [Exciseman's] Trot'. One of about twenty impressions taken of Bewick's only essay in lithography made during a visit to Edinburgh in 1823. It was done as a demonstration to show another artist in the printing house the true 'motion of a Horse in the long and full trot'. Reduced from $5\frac{3}{4} \times 7$ in. *Iain Bain.*

nor the two prints of prize cattle etched and engraved on copper do anything but reinforce the conclusion that Bewick was most successful and most himself when working on a small scale.

188. 'The Elephant'. One of a series of large cuts engraved in 1799-1800 for Gilbert Pidcock, proprietor of a travelling menagerie. This version is a reverse of the original and was probably engraved by one of the apprentices. Reduced from $5\frac{1}{2} \times 7\frac{1}{2}$ in. *Iain Bain.*

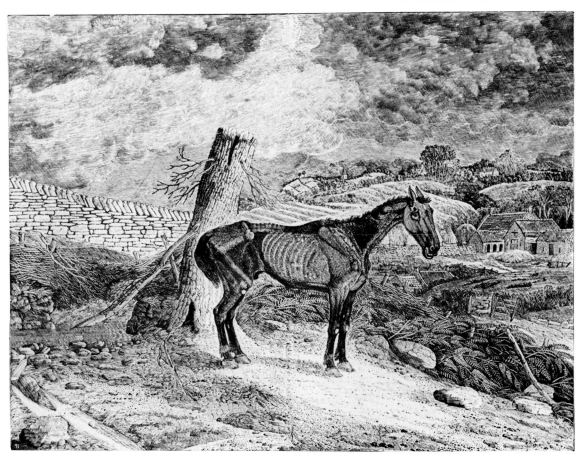

189-190. 'Waiting for Death', 1828, published posthumously by Bewick's son Robert in 1832, in a printed wrapper with a sheet of text. This was the last wood engraving Bewick was working on at the time of his death. Inspired by the large cheap prints of a moralistic or narrative content that he remembered seeing on cottage walls in his youth, this block was to have been augmented by two or three more to add tonal 'colour'. Engraving reduced from $8\frac{3}{4} \times 11\frac{1}{2}$ in. *Iain Bain*.

Watercolours and Drawings

Nearly a thousand of Bewick's drawings have survived – most of them studies or direct preliminaries for his engravings, and many show the crease marks of the process of transfer. In them can be seen the true source of his genius and his success as an engraver. He engraved with a painter's eye and his skill as a craftsman never dominated his artistry. There are a few larger drawings in the collections but hardly any are fully successful and underline the point already made that Bewick was only at ease on a miniature scale. Although the greater part of the surviving drawings are for the *British Birds*, there are enough of those for the *Quadrupeds* to see that the use of a preliminary study was an early practice and that for Bewick to draw direct to the wood was unusual.

Bewick's talent was early in evidence and of his schooldays he wrote: 'the margins of my Books and every space of spare & blank paper became filled with various kinds of devices or scenes I had met with & these were often accompanied with wretched Rhymes explanatory of them; but as I soon filled all the blank spaces in my Books, I had recourse, at all spare times to the Grave Stones & the Floor of the Church Porch, with a bit of Chalk to give vent to this propensity of mind . . . of Patterns or drawings I had none – the Beasts & Birds which enlivened the beautiful Scenery of Woods & Wilds surrounding my native Hamlet, furnished me with an endless supply of Subjects.'

Colour was first used extensively in the drawings for the *Birds*, perhaps prompted by the brightly coloured plumage of the foreign species in Tunstall's museum at Wycliffe which he began to draw in 1791, and it may have been a more helpful guide to him when translating the tones and textures into monochrome engraving. The contribution of his more talented apprentices has still to be fully explored: in his *Memoir* Bewick makes clear acknowledgment of Robert Johnson's assistance and unsurpassed skill in the colouring of his drawings.

The drawings were never exhibited in Bewick's lifetime and remain remarkably little known today. A few were given or sold to the more persistent collectors, but the main collection was guarded closely by the family until a final division was made, in bequest, between the British Museum and the Natural History Society of Northumbria.

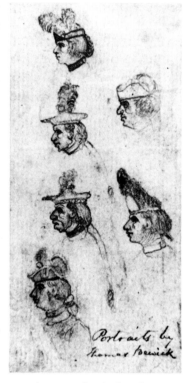

191. A group of early drawings, probably made during Bewick's walking tour of Scotland in 1776, after the end of his apprenticeship and shortly before leaving for London. *Trustees of the British Museum.*

192. The Cur Fox. Preliminary transfer drawing in pencil for the *History of Quadrupeds. NHSN.*

193. The Leicestershire Improved Breed Sheep. Preliminary transfer drawing in pencil for the *History of Quadrupeds. NHSN.*

194. The Rat. Preliminary study in pencil for the *History of Quadrupeds. NHSN.*

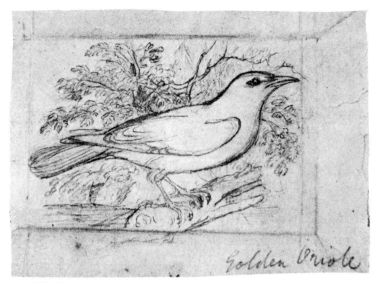

195. The Golden Oriole.
Preliminary transfer drawing in
pencil for the *History of British
Birds*. *NHSN*.

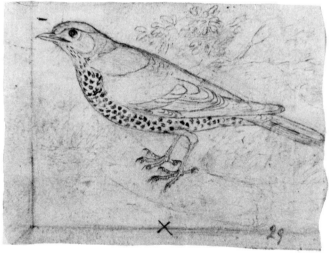

196. The Missel Thrush.
Preliminary transfer drawing in
pencil for the *History of British
Birds*. *NHSN*.

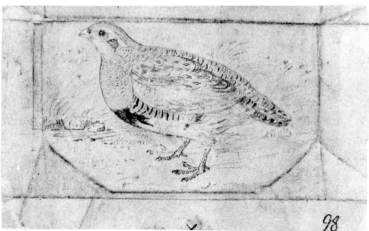

197. The Partridge. Preliminary
transfer drawing in pencil for the
History of British Birds. *NHSN*.

198. The Spotted Rail. Preliminary transfer drawing in pencil for the *History of British Birds*. *NHSN*.

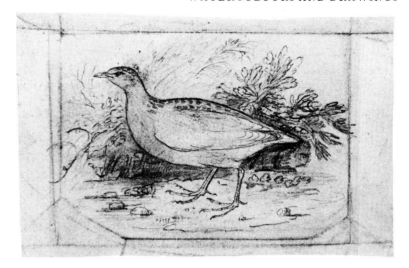

199. The Cuckoo. Preliminary transfer drawing in pencil for the *History of British Birds*. *NHSN*.

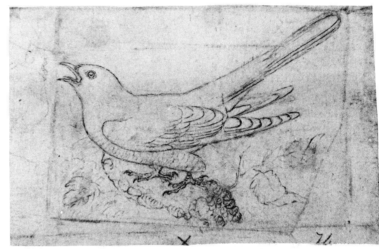

200. The Water Rail. Preliminary transfer drawing in pencil for the *History of British Birds*. *NHSN*.

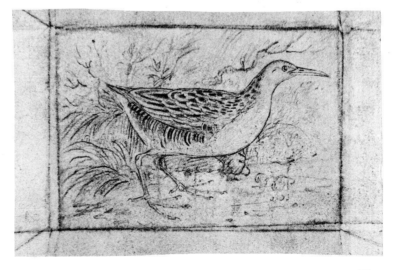

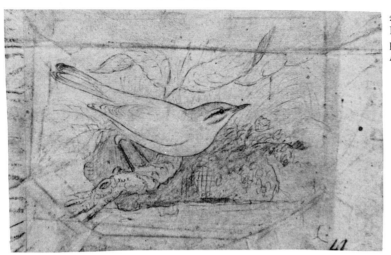

201. The Willow Wren. Preliminary transfer drawing in pencil for the *History of British Birds. NHSN.*

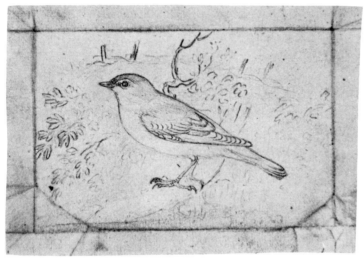

202. The Garden Warbler. Preliminary transfer drawing in pencil for the *History of British Birds. NHSN.*

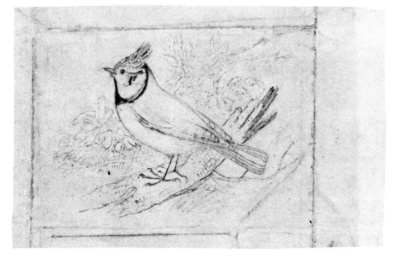

203. The Crested Tit. Preliminary transfer drawing in pencil for the *History of British Birds. NHSN.*

204. The Yellow Hammer. Preliminary transfer drawing in pencil for the *History of British Birds*. *NHSN*.

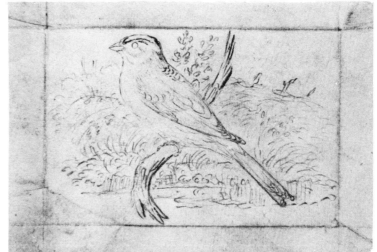

205. The Spotted Woodpecker. Preliminary transfer drawing in pencil for the *History of British Birds*. *NHSN*.

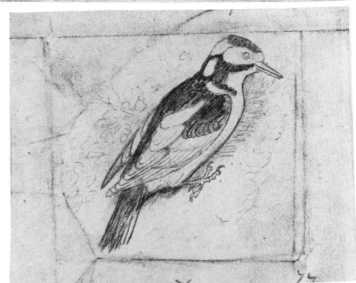

206. Poachers tracking a hare in the snow. Preliminary transfer drawing in pencil for a tail-piece in the *History of British Birds*. *NHSN*.

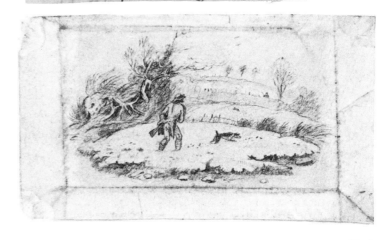

207. A man relieving himself against a wall. Preliminary transfer drawing in pencil for a tail-piece in the *History of British Birds*. *NHSN.*

208. A man drinking from the brim of his hat, at a roadside spring. Preliminary transfer drawing in pencil for the *History of British Birds*. *NHSN.*

209. Two itinerant fiddlers (one of them blind). Preliminary transfer drawing in pencil for a tail-piece in the *History of Quadrupeds*. *NHSN.*

210. The Chaffinch. Preliminary transfer drawing in watercolours for the *History of British Birds. BM.*

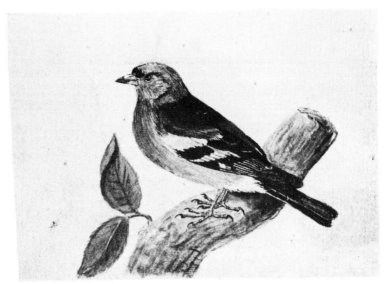

211. A group of boys sailing toy boats. Preliminary transfer drawing in watercolours for the title-page vignette in the *History of British Birds Vol. 2. B.M.*

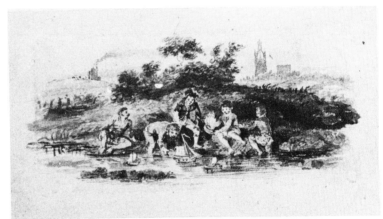

212. The Bullfinch. Preliminary transfer drawing in watercolours for the *History of British Birds. BM.*

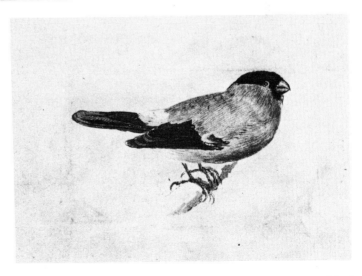

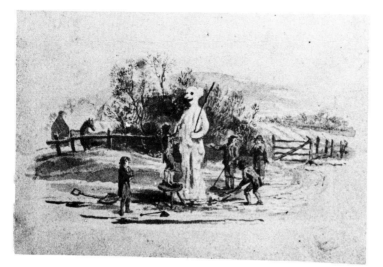

213. Boys building a snow-man.
Preliminary transfer drawing in
watercolours for a tail-piece in the
History of British Birds. BM.

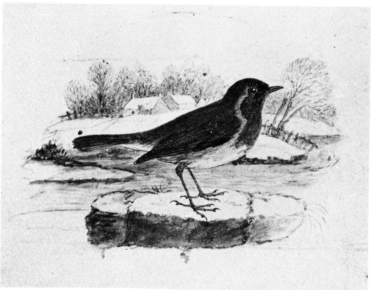

214. The Robin. Preliminary
transfer drawing in watercolours
for the *History of British Birds. BM.*

215. A wintry scene with skaters.
Preliminary transfer drawing in
watercolours for a tail-piece in the
History of British Birds. BM.

216. A meeting of two old soldiers. Preliminary transfer drawing in watercolours for a tail-piece in the *History of British Birds. BM.*

217. The Greenfinch. Preliminary transfer drawing in watercolours for the *History of British Birds. BM.*

218. A collier brig ashore at Bill Quay on the Tyne. Preliminary transfer drawing in watercolours for a tail-piece in the *History of British Birds. BM.*

219. A suicide hanging from a tree. Preliminary transfer drawing in watercolours for a tail-piece in the *History of British Birds*. BM.

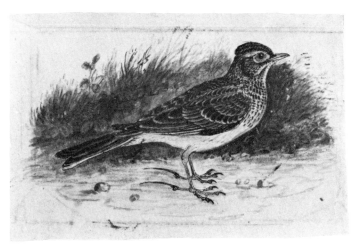

220. The Skylark. Preliminary transfer drawing in watercolours for the *History of British Birds*. *Iain Bain.*

221. Boys flying a kite. Preliminary transfer drawing in watercolours for a tail-piece in the *History of British Birds*. BM.

222. Ducks to market. Preliminary transfer drawing in watercolours for a tail-piece in the *History of British Birds*. BM.

223. The Sparrow-hawk. Preliminary transfer drawing in watercolours for the *History of British Birds*. BM.

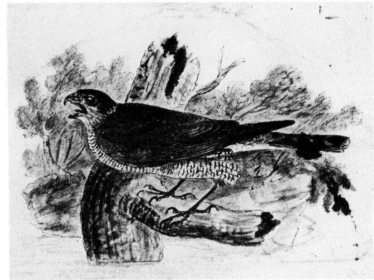

224. A boy leading a blind man across a stream. Preliminary transfer drawing in watercolours for a tail-piece in the *History of British Birds*. BM.

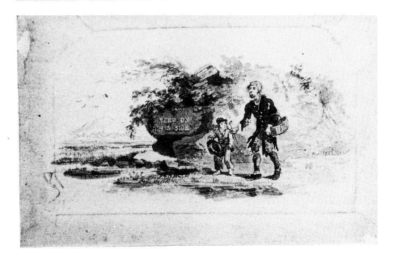

225. A man swimming his cow across a river to evade the toll. Preliminary transfer drawing in watercolours for a tail-piece in the *History of British Birds*. *BM.*

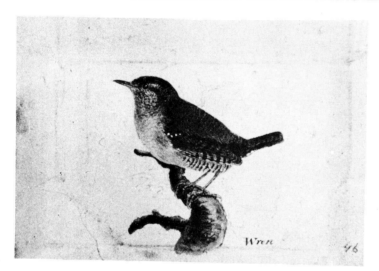

226. The Wren. Preliminary transfer drawing in watercolours for the *History of British Birds*. *NHSN.*

227. A miller lying drunk under a hedge on the King's birthday. Preliminary transfer drawing in watercolours for a tail-piece in the *History of British Birds*. *BM.*

228. An angler wading in a river.
Drawing in watercolours of a
tail-piece in *History of British Birds*.
This appears to have no signs of
transfer work and is not a reversal
of the engraving: it may possibly
have been drawn later. *BM.*

229. The Titlark. Preliminary
transfer drawing in watercolours
for the *History of British Birds*. *BM.*

230. Two dyers of Ovingham
carrying a tub of 'night water' to
the dye house. Preliminary transfer
drawing in watercolours for a
tail-piece in the *History of British
Birds*. *NHSN.*

The Apprentices

Bewick refers to his apprentices in several passages of his *Memoir*. In one large section, omitted in the first edition of 1862, he expands upon the faults and merits of a number of them. In another he writes: ' – I had formed a plan of working alone without any assistance from Apprentices, or of being interrupted by any one – and I am not certain at this day whether I would not have been happier in doing so than in the way I was led to pursue – I had often, in my lonely walks, debated this business over in my mind, but whether it would have been for the better or the worse, I can now only conjecture – I tried the one plan & not the other – perhaps each way might have had advantages and disadvantages – I would not have experienced the envy and ingratitude of some of my pupils, neither should I, on the contrary, have felt the pride & the pleasure I derived from so many of them having received medals or premiums from the society for the Encouragement of Arts – & also of their taking the lead, as Engravers on Wood in the Metropolis. Notwithstanding this pride & this pleasure, I am inclined to think I should have had (ballancing the good against the bad) more pleasure in working alone for myself, than with such help, as apprentices afforded, for with some of them I had a deal of turmoil & trouble – '.

Although there were many others, the apprentices of some accomplishment numbered about eighteen – spread throughout Bewick's time as master. Not all of them were wood engravers: Robert Johnson was principally a draughtsman and colourist who became skilled in copper-plate etching and engraving; John Harrison, Bewick's nephew, specialised in 'writing' or lettering engraving on copper; and John Laws was extremely successful as an ornamental engraver on silver. Their normal term was seven years, and they were usually paid for their work during their final three years; but conditions of engagement differed – depending on the premium paid at the time of their being indentured. Several worked for a time before being signed on – either on trial, or because they had not yet reached the age of 14. Of the wood engravers, all displayed a more or less distinct manner in their work as some of the examples on the following pages show.

John Bewick 1760-1795

APPRENTICED 1777 – 1782

John Bewick showed much promise as a wood engraver, but sadly he died of consumption at the early age of 35 before coming to a full maturity in his art. Most of his working life was spent in London where he did much work for the publishers of children's books such as Newbery and Dr Trusler. His nature was more light-hearted than his brother's and he had a good eye for the fashions of the time. His work and his letters display much of his gaiety of spirit. The manner of his engraving particularly in the foliage of trees and the marking of rocks displays a strong horizontal bias. A small group of his drawings is now in the British Museum, mostly early work, though five watercolour vignettes for the *Poems by Goldsmith and Parnell*, 1795, have a control and high finish that matches his brother's skill.

231. *Pieces of Ancient Popular Poetry . . .* Joseph Ritson, 1791, with engravings by John Bewick. *Iain Bain.*

232. BELOW RIGHT: *The Beauties of History . . .* by William Dodd, 1796, with engravings by John Bewick. *Iain Bain.*

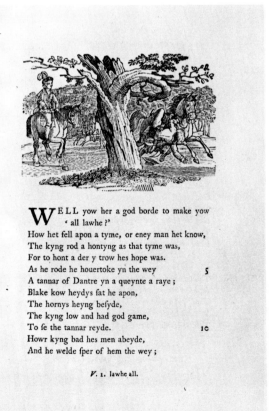

WELL yow her a god borde to make yow
' all lawhe ?'
How het fell apon a tyme, or eney man het know,
The kyng rod a hontyng as that tyme was,
For to hont a der y trow hes hope was.
As he rode he houertoke yn the wey 5
A tannar of Dantre yn a queynte a raye ;
Blake kow heydys fat he apon,
The hornys heyng befyde,
The kyng low and had god game,
To fe the tannar reyde. 10
Howr kyng bad hes men abeyde,
And he welde fper of hem the wey ;

V. 1. lawhe all.

THE
BEAUTIES OF HISTORY;
OR,
Pictures of Virtue and Vice:
DRAWN FROM
EXAMPLES OF MEN,
*EMINENT FOR THEIR VIRTUES OR INFAMOUS
FOR THEIR VICES.*
SELECTED FOR THE
INSTRUCTION AND ENTERTAINMENT
OF
YOUTH.

BY THE LATE W. DODD, LL. D.

THE SECOND EDITION,
*With confiderable Additions and Improvements, and
ornamented with Vignettes by* BEWICK.

London:
PRINTED FOR VERNOR AND HOOD, BIRCHIN-LANE,
CORNHILL; F. NEWBERY, CORNER OF ST.
PAUL'S CHURCH-YARD, AND DARTON
AND HARVEY, GRACE-CHURCH-
STREET. 1796.

Proverbs Exemplified,

AND ILLUSTRATED BY

PICTURES FROM REAL LIFE.

TEACHING MORALITY AND A KNOWLEDGE
OF THE WORLD;

WITH PRINTS.

Designed as a Succession-Book to Æsop's Fables.

After the Manner, and by the Author, of
HOGARTH MORALIZED.

PRINTED FOR AND PUBLISHED BY THE REV. J. TRUSLER,
AND SOLD AT THE Literary-Press, No. 62, WARDOUR-
STREET, SOHO, AND BY ALL BOOKSELLERS.
Entered at Stationer's Hall.
[PRICE THREE SHILLINGS, HALF-BOUND.]
LONDON, MAY, 1, 1790.

[65]

Hedges have Eyes, and Walls have Ears.

THIS is a Proverb to teach worldly policy,
and put the incautious upon their guard,
with respect not only to their words, but their ac-
tions. Hedges are no greater security against a
prying eye, than is a wall against a listening ear.
As it is easy to see through a hedge, and discover
what is *doing* on the other side, so is it as easy to
hear on one side of a wall, what is *saying* on the

G 3 other.

233-234. The title and a text page
from *Proverbs Exemplified* . . . by
the Rev. J. Trusler, 1790, with
engravings by John Bewick.
Iain Bain.

235. A vignette by John Bewick
for Le Grand's *Fabliaux*, translated
by Gregory Way, 1796. *Pease
Collection.*

Robert Johnson 1770-1796

APPRENTICED 23 August 1787 – 23 August 1794

Born the son of a Shotley joiner and cabinet-maker, and a servant of Bewick's parents, he was one of the most talented of his pupils, not as a wood engraver, but as a draughtsman and colourist. Delicate in health, Bewick kept him out of the confined atmosphere of the workshop as much as possible, and sent him out of doors to draw from nature. In a passage in his *Memoir* omitted from the first edition of 1862, Bewick is quite unequivocal about Johnson's skill: .'. . . the next thing I put him to was that of colouring chiefly my own designs . . . the practical knowledge I had attained in colouring was imparted to him . . . he soon coloured them in a stile superior to my own hasty productions . . . in this way he became super excellent. . .'. After his apprenticeship he took a case against his masters and won back cash paid to them for drawings sold to the Earl of Bute which he had done while their apprentice – claiming unjustly that watercolour painting was not part of the workshop training. He died in painful circumstances in Perthshire while working on a commission for Pinkerton's *Scottish Portraits* of 1799. Among the few examples of his drawing known to have survived, some display a remarkable finish and delicacy of handling. The degree to which he contributed to the tailpieces in the *British Birds* has yet to be resolved: many of the original watercolours for these display in their landscape backgrounds a delicacy not apparent in the backgrounds to his master's drawings of the birds.

236. An early drawing by Robert Johnson from a collection of his work in an album. *Laing Gallery.*

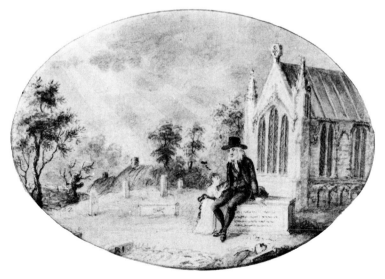

237. 'The Rev. Christopher Gregson sitting on a tomb in Ovingham churchyard', a drawing in watercolours, by Robert Johnson, c. 1790. original size. *Pease Collection.*

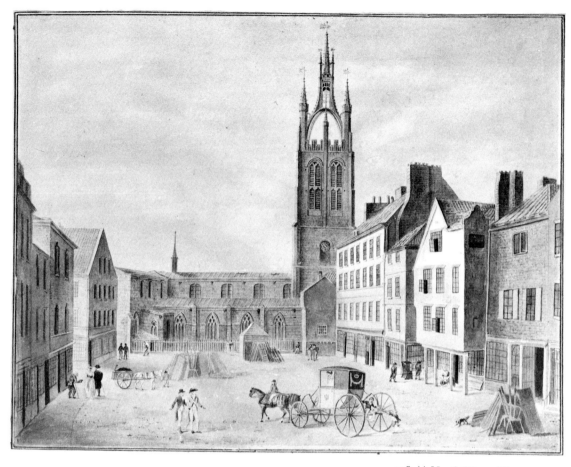

238. 'A North View of St. Nicholas' Church' a drawing in watercolours, $11\frac{1}{2} \times 14$ in. by Robert Johnson, c.1795. This was engraved on wood by Charlton Nesbit in 1798. *Laing Gallery.*

239. An early drawing in pencil and watercolours by Robert Johnson from a collection of his work in an album. *Laing Gallery.*

240. A drawing of a milkmaid in
pencil and watercolours by Robert
Johnson, original size. *Laing
Gallery.*

241. 'A Man of Fashion', early
pencil drawing by Robert Johnson
original size. *Laing Gallery.*

242. 'Bamborough Castle', drawn
in pen and wash by Robert
Johnson, $8\frac{1}{4} \times 13\frac{3}{4}$ in., 1792.
Laing Gallery.

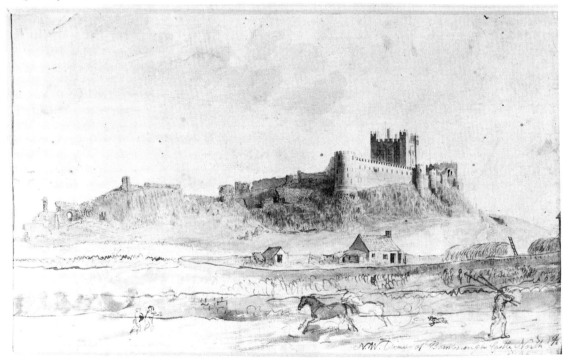

Luke Clennell 1781-1840

APPRENTICED 8 April 1797 – 7 April 1804

Born at Ulgham near Morpeth, he contributed many tail-pieces to the second volume of the *British Birds*, as well as the greater part of the engravings in Hodgson's *The Hive*, 1806. He moved to London in 1804 and worked on many books such as Samuel Rogers' *Pleasures of Memory*, 1810 (in the 'black line' manner after Stothard) and Cowper's *Poems* (after Thurston). He was one of the very few of Bewick's pupils truly 'gifted with the painter's eye'. His rare watercolours are now much prized, and in their later manner display a broad and vigorous handling reminiscent of Girtin. He became insane in 1817 and tragically remained so until his death.

243-244. A tail-piece engraved for the *History of British Birds* by Luke Clennell, and his larger watercolour drawing of the same subject, 5 × 10 in., *Laing Gallery*. Clennell's free and spirited handling can be seen in both — the sweeping broad-leaved foliage in the foreground of the engraving is typical of his manner.

245. A preliminary study in watercolours by Luke Clennell, for a trade card for A. Cunningham of Edinburgh. Original size. *Laing Gallery*.

246. 'Bywell Castle and the Ruins of a Bridge' by Luke Clennell, watercolours, $9\frac{3}{4} \times 16$ in. *Laing Gallery*.

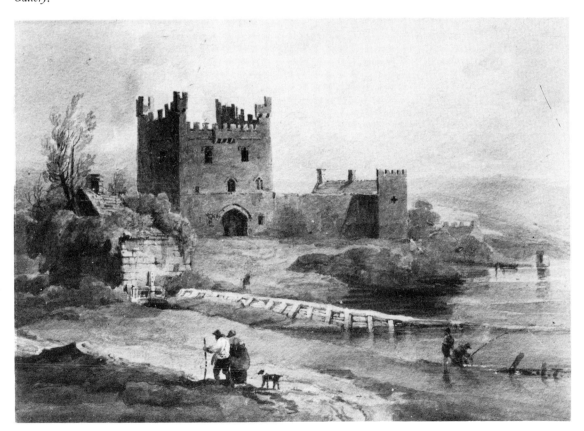

247-248. Two tail-piece engravings by Luke Clennell for the *History of British Birds*, in which his freedom of handling is most clearly seen.

249. A tail-piece engraving by Luke Clennell for the *Reactions in Natural History*, 1815, in which can be seen the looser style he adopted when having to work for his living in the London trade. *Pease Collection*.

John Anderson 1778-

APPRENTICED 10 September 1792 – 1799

Son of Dr James Anderson of Edinburgh, editor of *The Bee* and one of Bewick's customers. He engraved for Bloomfield's *The Farmer's Boy*, 1800, and Maurice's *Grove Hill* 1799. He went abroad about 1804 and was lost to wood engraving.

251. A vignette engraved by John Anderson for *The Farmer's Boy* by Robert Bloomfield, 1800. It displays the thin horizontally biased foliage typical of his work. *Iain Bain.*

Charlton Nesbit 1775-1838

APPRENTICED 5 June 1790 – 1797

Born the son of a keelman at Swalwell, Nesbit contributed a number of cuts to the *British Birds*, the *Poems by Goldsmith & Parnell*, 1795, and Le Grand's *Fabliaux*, 1796 and 1800, before leaving for the London trade in 1799. There his work appeared in Ackermann's *Religious Emblems*, 1809, Puckle's *The Club*, 1817, and *Northcote's Fables* 1828: all designed by their publishers to display the talents of the finest wood engravers of the day.

250. A vignette engraved by Charlton Nesbit for *Hobbinol, Field Sports, and the Bowling Green*, by William Somervile, 1813. A greatly skilful engraver, his success came from his work for the draughtsmen who specialised in drawing on wood for the trade engravers. *Laing Gallery.*

Isaac Nicholson 1789-1848

APPRENTICED 18 May 1804 – 6 July 1811

Born at Melmerby in Cumberland, he was a skilled engraver but wanting in artistic talent. At the end of his time he continued to work in Newcastle and engraved much for Charnley's *Select Fables*, 1820, and *Fisher's Garlands*, 1822–42 – work often incorrectly attributed to Bewick.

252-253. Two title-page vignettes engraved by Isaac Nicholson for Charnley's *Fisher's Garland*, 1822-42. A very 'mechanical' engraver, his copy of his master's 'Angler' is a poor shadow of the original. *Iain Bain.*

William Harvey 1796-1866

APPRENTICED 27 November 1809 – 9 September 1817

A Newcastle man, Harvey set up in business in London and eventually became John Thurston's successor as the principal designer for the wood engraving trade. His exquisitely fine work appears in innumerable books such as *Northcote's Fables*, 1828 and 1833, and, as designer, in Lane's *Arabian Nights*, 1849–51. With William Temple he worked extensively on Bewick's *Fables of Aesop*, 1818.

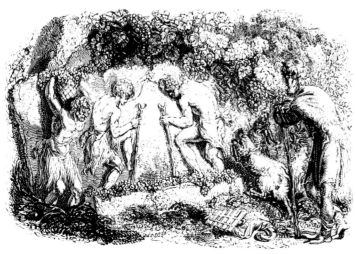

254. A vignette engraved by William Harvey for Henderson's *History of Wines*, 1824. It displays the delicate manner, with much 'black line' work, adopted by the London trade when engraving a very finely finished drawing made directly on the wood block. *Iain Bain.*

John Jackson 1801-1848

APPRENTICED 19 June 1823 – 12 June 1824

Born at Ovingham, Jackson was not apprenticed to Bewick until he was 23, having joined him after the bankruptcy of his former masters, Armstrong & Walker of Newcastle. After a year he moved to London to work with William Harvey who had ended his apprenticeship in 1817. Jackson's work as a wood engraver, reproducing the drawings of others, had great mechanical excellence and is to be seen at its best in *Northcote's Fables*, 1828, Lane's *Arabian Nights*, 1849–51, and Charles Knight's *Penny Magazine*. The *Treatise on Wood Engraving*, 1839, through which his name is now best known and which was actually written by W. A. Chatto, contains a number of his best engravings.

255-256. The Partridge from the *History of British Birds*, with Jackson's copy of his master's original (below)—from his *Treatise on Wood Engraving*, 1839. Technically highly finished, Jackson's version loses the tonal harmony of the original. *Iain Bain*.

Robert Elliot Bewick 1788-1849

APPRENTICED 26 May 1804 – 26 May 1810

The skilful draughtsmanship of Bewick's son Robert has been very largely ignored. Though he lacked his father's originality and fertile imagination, he was nevertheless a very accurate observer, and his fine drawings of fishes show a considerable skill. He had a great interest in architectural drawing and perspective. As a wood engraver he showed no more than competence, but as an etcher and engraver on copper he deserves attention. His development as an artist was kept in check by indifferent health and a want of confidence aggravated by the powerful personality of his father. About 150 of his drawings are now in the British Museum.

257. A tail-piece engraving by Robert Bewick for the unpublished *History of British Fishes*.

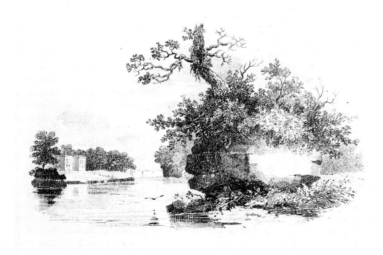

258. An etching on copper, possibly for a bookplate, by Robert Bewick. From an impression in Julia Boyd's *Bewick Gleanings*, 1886.

259. 'Ovingham Church', a highly finished pen and ink drawing by Robert Bewick, 1843, $4\frac{5}{8} \times 7\frac{3}{8}$ in. *Trustees of the British Museum.*

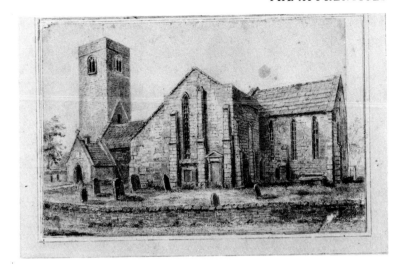

260. 'Elizabethan House at Newcastle', a highly finished pen and ink drawing by Robert Bewick, $6\frac{1}{2} \times 9\frac{3}{8}$ in. *Trustees of the British Museum.*

261. A watercolour study of a Dace, prepared for the unpublished *History of British Fishes* by Robert Bewick, $5\frac{1}{8} \times 9\frac{1}{4}$ in. *Trustees of the British Museum.*

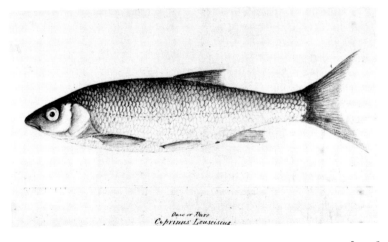

Retrospect

These final pages show something of the many books relating to Bewick and his work that have continued to appear, without marked pause, since the time of his death. Two editions of the *British Birds* were published by his son in 1832 and 1847, and a Memorial Edition of his works in 5 volumes was published between 1884 and 1887, making use of the original blocks for the last time. The most remarkable feature of all that has been written about Bewick until relatively recent years, is the very great neglect of the vital material to be found in his surviving correspondence and business records.

263. OPPOSITE LEFT: *The Bewick Collector : A Descriptive Catalogue . . .* by Thomas Hugo, 1866. This and its supplement have long remained a principal source of information in spite of a certain unreliability and its sometimes 'hopeful' attributions. *Pease Collection.*

262. Jane Bewick's bound-up proof sheets of the first edition of her father's autobiographical *Memoir*, published posthumously in 1862. Her notes in this opening show that she was not best pleased with the interference of her cousin, the printer, Robert Ward. Although there were four subsequent editions, it was not until 1975, that the complete unaltered text was published. *Iain Bain.*

206 MEMOIR OF THOMAS BEWICK.

abridgement of the laws of England would perhaps fill fifty folio volumes. These laws, at the time they were made, might be good and proper, but most of them are now inapplicable and obsolete. To amend them seems impossible, and an act to amend or explain an act, by adding confusion to confusion, is truly farcical. It is a pity that the whole of them cannot be abolished at once, and short and clear new ones substituted in their stead. As they stand at present, few men can understand them, and to men of plain, good sense, or of ordinary capacities, they appear altogether a great mass of unintelligible matter, or a complete " riddle-me-ree." This may, indeed, be intended or winked at; for it gives employment to a great number of men of the law, of all kinds of character, from the basest up to others who are ornaments to their country. Indeed, were it not for the latter description, the rest would not be endurable. They are more to be dreaded than highwaymen and housebreakers, and as such are viewed by the thinking part of the community; but the former find employment from clients of their own character, who trust to them for their ability in twisting, evading, and explaining the law away.

In passing through life, it has fortunately been my lot to have been intimate with both military and naval gentlemen, as well as with those of the learned professions; and, though several of each class have stood high in the estimation of the world, for their gentlemanly manners and unsullied worth—to which I may be allowed to add my testimony,

MEMOIR OF THOMAS BEWICK. 207

as well as to acknowledge the debt of gratitude I owe some of them for their kindness and attention —yet, on taking a comparative survey of the whole, I cannot help giving a preference to medical men; for, besides their learning and attainments in common with other professions, they appear to me, generally, to be further removed from prejudice, more enlightened, and more liberal in their sentiments than the other labourers in the vineyards of science and literature.

The Bewick Collector.

A DESCRIPTIVE CATALOGUE

OF THE WORKS OF

THOMAS AND JOHN BEWICK;

INCLUDING CUTS, IN VARIOUS STATES, FOR

BOOKS AND PAMPHLETS,

PRIVATE GENTLEMEN, PUBLIC COMPANIES,

EXHIBITIONS, RACES, NEWSPAPERS,

SHOP CARDS, INVOICE HEADS, BAR BILLS,

COAL CERTIFICATES, BROADSIDES,

AND OTHER MISCELLANEOUS PURPOSES,

AND

WOOD BLOCKS.

With an Appendix of Portraits, Autographs, Works of Pupils, &c. &c.

The whole described from the Originals

CONTAINED IN THE LARGEST AND MOST PERFECT COLLECTION
EVER FORMED,

AND ILLUSTRATED WITH A HUNDRED AND TWELVE CUTS.

BY

THOMAS HUGO, M.A., F.R.S.L., F.S.A., &c.,

Honorary Fellow and Honorary Member of various Literary and Archæological Societies,
Rector of All Saints, Bishopsgate,
and Chaplain to the Honourable Artillery Company;

THE POSSESSOR OF THE COLLECTION.

LONDON:
LOVELL REEVE AND CO, 5, HENRIETTA STREET,
COVENT GARDEN.

MDCCCLXVI.

A

DESCRIPTIVE AND CRITICAL

CATALOGUE OF WORKS,

ILLUSTRATED BY

THOMAS AND JOHN BEWICK,

WOOD ENGRAVERS,

OF NEWCASTLE-UPON-TYNE;

WITH AN APPENDIX OF THEIR MISCELLANEOUS ENGRAVINGS,

BRIEF SKETCHES OF THEIR LIVES,

AND

NOTICES OF THE PUPILS OF THOMAS BEWICK.

LONDON:
JOHN GRAY BELL, BEDFORD STREET, COVENT GARDEN.

MDCCCLI.

264. TOP RIGHT : John Gray Bell's *Catalogue of Works illustrated by Thomas and John Bewick*, 1851. Bell was a member of a well-known Newcastle family of collectors and much of his information, being close to original sources, is valuable. *Pease Collection.*

265. J. E. Harting's *Our Summer Migrants*, 1875, and his edition of Gilbert White's *Selborne* of the same year. Both books purport to be illustrated by Bewick at a time when the original blocks were still in the possession of his daughters. The blocks used were in fact extremely accurate copies, but the sharpness and precision of the work gives it a coldness of effect quite without the harmony of the originals. *Iain Bain.*

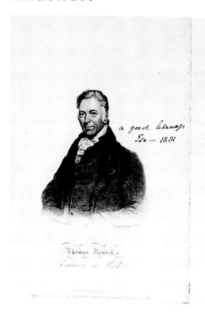

a good likeness
Isa — 1881

Thomas Bewick
Engraver in Wood

CATALOGUE
OF
AN EXCEEDINGLY CHOICE AND VARIED
COLLECTION
OF
Books and Wood Engravings
BY OR RELATING TO
THOMAS & JOHN BEWICK,
AND THEIR PUPILS,
COLLECTED BY
MR. EDWIN PEARSON.

Many of the Volumes are in Elegant Bindings by Messrs. Bedford,
Lewis, Zaehnsdorf, Hayday, and others.

The Whole Alphabetically Arranged for facility of Reference.

WITH INTRODUCTORY NOTICE

LONDON.
Printed by J. Davy & Sons, 137, Long Acre.
1868.

266. The Catalogue of Edwin Pearson's Collection, 1868. Isabella Bewick's approval of the frontispiece portrait can be seen in the manuscript note. The title-page vignette was by Isaac Nicholson, and typifies the acquisitive inaccuracy of some of the great Victorian collectors. *Iain Bain.*

267. Robert Robinson's Life of Bewick, 1887: a rambling but nevertheless useful source book. Robinson was a Newcastle bookseller who saw much of Bewick's daughters in their old age when filial piety and failing memories tended to confuse the story. *Pease Collection.*

268. David Croal Thomson's Life: still a valuable work, it was written without assistance from the family who refused to see Thomson, a professional art historian and London Gallery manager. *Pease Collection.*

THOMAS BEWICK

His Life and Times

BY

ROBERT ROBINSON

With Two Hundred Illustrations

NEWCASTLE
PRINTED FOR R. ROBINSON, PILGRIM STREET
Jubilee of Queen Victoria
MDCCCLXXXVII

THE LIFE AND WORKS

OF

THOMAS BEWICK

BEING AN ACCOUNT OF

HIS CAREER AND ACHIEVEMENTS IN ART

WITH

A NOTICE OF THE WORKS OF JOHN BEWICK

BY

DAVID CROAL THOMSON

With One Hundred Illustrations

LONDON
"THE ART JOURNAL" OFFICE, IVY LANE, PATERNOSTER ROW
1882

269. The sale catalogue of Edwin Pearson's collection of wood blocks, 1895. The last great accumulation, which contained much acquired at the Hugo sale. *Pease Collection.*

270. *1800 Woodcuts of Thomas Bewick and His School*, Dover Books, New York, 1962 — the principal source for all modern decorators of books and jobbing print. About 900 engravings are Bewick's, the remainder being an interesting array of general 19th century work, some of very poor quality. *Pease Collection.*

271. *Wood Engravings of Thomas Bewick*, selected and introduced by Reynolds Stone, 1953. The engravings are very well reproduced in collotype, and Mr Stone, who continues the Bewick tradition as an engraver, provides a valuable introduction. *Pease Collection.*

CATALOGUE
OF
AN EXTRAORDINARY
Assemblage of Many Thousands
OF
ENGRAVED WOOD-BLOCKS
FORMING
THE MOST EXTENSIVE COLLECTION EVER BROUGHT TOGETHER
OF THE
Original Engravings on Box-wood
BY
THOMAS AND JOHN BEWICK,
Consisting of Sets of Blocks to Bewick's Select Fables, *Newcastle*, 1784 and 1820;
Gay's Fables; Dance of Death; Tommy Trip; Thornton's Herbal, and other
Important Works ; with
SOME HUNDREDS OF OLD ENGLISH TOY BOOK BLOCKS, &c. ;
LARGE BLOCKS OF LIONS, AND BULL, WAITING FOR DEATH, &c. ;
Steel and Copper Plate Portraits of Bewick, &c.
ALSO
ORIGINAL AND CURIOUS BLOCKS BY GEORGE AND ROBERT CRUIK-
SHANK, AUSTIN, SEYMOUR, KENNY MEADOWS, AND
OTHER CONTEMPORARY ARTISTS,
Formerly in the Hugo Jupp, Pearson, and other Collections.
TOGETHER WITH
THE ORIGINAL BLOCKS, STEREOTYPE-PLATES, AND PUBLISHING RIGHTS OF BEWICK'S
Select Fables.
(Longmans' Edition, 1878.)

WHICH WILL BE SOLD BY AUCTION,
BY ORDER OF THE TRUSTEES UNDER A DEED OF GIFT, BY
MESSRS.
SOTHEBY, WILKINSON & HODGE,
Auctioneers of Literary Property & Works Illustrative of the Fine Arts.
AT THEIR HOUSE, No. 13, WELLINGTON STREET, STRAND, W.C.
On FRIDAY, the 19th of APRIL, 1895, and following day,
AT ONE O'CLOCK PRECISELY.

MAY BE VIEWED TWO DAYS PRIOR. CATALOGUES MAY BE HAD.

DRYDEN PRESS: J. DAVY & SONS, 137, LONG ACRE, W.C.

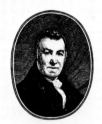

WOOD ENGRAVINGS OF
THOMAS BEWICK

REPRODUCED IN COLLOTYPE

Selected, with a Biographical Introduction, by
REYNOLDS STONE

*From the portrait by William Nicholson, R.S.A.,
in the Laing Art Gallery, Newcastle, engraved
on wood by Reynolds Stone*

RUPERT HART-DAVIS
SOHO SQUARE LONDON
1953

Further Reading

BIBLIOGRAPHY

The most scholarly record of Bewick's principal works is Sidney Roscoe's *Thomas Bewick, a Bibliography Raisonné*, Oxford, 1953, reprinted 1973; Thomas Hugo's *The Bewick Collector*, 1866, and its supplement, 1868, is by contrast a slipshod work – though valuable for the vast amount of material surveyed it contains much of doubtful attribution. The fine Bewick collection of J. W. Pease now in the Central Library, Newcastle upon Tyne, is usefully recorded in the *Catalogue of the Bewick Collection (Pease Bequest)* by Basil Anderton and W. H. Gibson, 1904. *A Check-list of the Manuscripts of Thomas Bewick*, compiled by Iain Bain, 1970, is the first survey of Bewick's surviving correspondence and other papers.

BIOGRAPHY

The most useful 19th-century works based on personal acquaintance are: G. C. Atkinson, 'Sketch of the Life and Works of the late Thomas Bewick' in the *Transactions of the Natural History Society of Northumberland . . .*, i. 1831; and J. F. M. Dovaston's 'Some Account of the Life, Genius and Personal Habits of the late Thomas Bewick' in Loudon's *Magazine of Natural History*, Nos. 9–12, 1829–30. Other substantial 19th-century studies are noticed on pages 110–11. In the present century Montague Weekley's *Thomas Bewick*, 1953, gives us the only modern biography written with much insight but with insufficient reference to the manuscript sources which have since become more readily accessible. Other shorter appreciations are given in Graham Reynolds' *Thomas Bewick: a resumé of his Life and Work*, 1949, and John Rayner's *A Selection of Engravings on Wood by Thomas Bewick*, 1947. The most valuable supplement to Bewick's own *Memoir* (edited by Iain Bain, Oxford, 1975) and full of detail relating to the later years of his life, is to be found in *Bewick to Dovaston: Letters 1824–28*, edited by Gordon Williams, 1968.